LEONARDO DA VINCI

ANATOMICAL DRAWINGS
FROM THE ROYAL LIBRARY
WINDSOR CASTLE

THE METROPOLITAN MUSEUM OF ART
NEW YORK

The exhibition has been made possible by a grant from
Fiat S.p.A.
and the Banca Nazionale del Lavoro, Rome, Italy.
Additional support has been received from the National
Endowment for the Arts, Washington, D.C., a federal agency.
An indemnity has been granted by the Federal Council on the
Arts and the Humanities.

Exhibition held at THE METROPOLITAN MUSEUM OF ART, New York

January 20, 1984, through April 15, 1984

PUBLISHED BY The Metropolitan Museum of Art, New York

Bradford D. Kelleher, Publisher

John P. O'Neill, Editor in Chief

Polly Cone, Editor

Peter Oldenburg, Designer

Typeset by the Open Studio, Rhinebeck, New York.
Printed and bound by Rae Publishing Co., Inc., Cedar Grove, N.J.

All drawings reproduced by gracious permission of Her Majesty Queen Elizabeth II

ON THE COVER:
Male nude seen from the back. Catalogue number 50

CONTENTS

FOREWORD

THE USE OF superlatives to describe Leonardo da Vinci, the most sensitive and relentlessly curious of men, is entirely justified. Moreover, his consummate draftsmanship and sovereign intelligence are often best preserved and seen in his works on paper. The Royal Library at Windsor Castle, with its collection of six hundred drawings by Leonardo, constitutes the richest enclave of this master's works on paper.

In the spring of 1981, the Metropolitan Museum, in collaboration with the J. Paul Getty Museum in Malibu, California, mounted an exhibition of fifty of Leonardo's nature studies, an unprecedented and indeed generous loan from the Royal Library at Windsor. *Quod erat expectandum,* the exhibition was an enormous success. We now delight in offering our visitors another exhibition of Leonardo's drawings, a superior selection of fifty anatomical studies, works that are widely acknowledged as among the finest of Leonardo's creations on paper. Remarkable for their scientific exactness, these works are moving testimony not only to the artist's probing and fecund genius, but also to the most ennobling of life's miracles—the human anatomy.

We are most grateful to Her Majesty the Queen, who graciously agreed to lend this particular core of Leonardo's work. For the selection of the drawings, we should like to thank Sir Robin Mackworth-Young, Royal Librarian, Windsor Castle, and the Hon. Mrs. Roberts, Curator of the Print Room, Royal Library.

With respect to the installation of the exhibition in New York, I should like to acknowledge the respective roles of James Pilgrim, Deputy Director of the Metropolitan, Jacob Bean, Curator of Drawings, Helen Mules, Assistant Curator of Drawings, and John Buchanan, Registrar, for overseeing the myriad aspects entailed in mounting the exhibition. We are also grateful to Paul Williams, London, who was assisted by Hamish Muir, London, for their skillful installation design.

PHILIPPE DE MONTEBELLO
Director, The Metropolitan Museum of Art

PREFACE

O F ALL THE MEN of genius who played a part in the Italian Renaissance, none is more remarkable than Leonardo da Vinci. Master of any discipline to which he set his hand—painting, sculpture, architecture, anatomical dissection, engineering, music—he exemplified the spirit of inquiry about nature to which the vast corpus of modern scientific knowledge owes its origin.

The impact of his genius has been preserved for us more directly than that of most of his contemporaries by his extraordinary talent for drawing. This he used for recording his thoughts, experiences, and discoveries much as a diarist or a scholar uses words, thus preserving for a later age intimate access to the very workings of his mind. An idea is set down as it emerges, perhaps filling a vacant space on an already crowded sheet. A few strokes of chalk, pen, or stylus suffice not only to record some outer object—or some product of the imagination—but also to invest it with an inner energy, often of striking intensity. Sometimes he is processing a detail for a larger composition, sometimes simply recording knowledge. Words are not excluded, but are usually supplementary, appearing as comment by the side of some sketch. One such comment on an anatomical drawing explains his method. The use of drawing gives "knowledge that is impossible for ancient or modern writers [to convey] without an infinitely tedious example and confused prolixity of writing and time."

Nowhere is this method better exemplified than in the anatomical series of drawings, whose interest is as much scientific as artistic. In the primitive conditions of the late fifteenth century, and with no medical training, this astonishing man acquired a knowledge of human anatomy far in advance of the medical profession of his day. And the studies in which he recorded his findings bear comparison as works of art with his exquisite portrayals of the exterior of the human form and of horses, or with his dramatic representations of mountainous landscapes.

On Leonardo's death the contents of his studio, which included several thousand drawings, passed to his favorite pupil, Francesco Melzi, whose handwriting may be seen on 19B in the present exhibition. On Melzi's death (about 1570) most of the collection was bought by the sculptor Pompeo Leoni, who rearranged the folios and bound them into volumes. Leoni, who was court sculptor to the king of Spain, took some of the volumes to Madrid. After his death in 1609, one volume, containing examples of every field in which Leonardo worked, was acquired by the celebrated English collector Thomas Howard, Earl of Arundel, who brought it to England. While it belonged to him some of its drawings were engraved by Wenceslaus Hollar. Arundel had to leave the country during the Civil War, and it is uncertain whether or not he took the volume with him. According to Count Galeazzo Arconati, who gave other Leonardo manuscripts to the Ambrosian Library in Milan, drawings concerning anatomy, nature, and color were "in the hands of the King of England" before 1640. This statement, and the fact that virtually all the surviving anatomical drawings by Leonardo are now in the Royal Collection, having formed part of the volume bought by Arundel, suggests that the volume did not leave the

country, but was acquired by King Charles I. Others have surmised that it may not have reached the Royal Collection until after the restoration of King Charles II, to whom it could well have been sold or presented by Sir Peter Lely, one of the keenest collectors of drawings of his day. By whatever route it reached the Royal Collection, it is recorded as being in the possession of Queen Mary II in 1690, a year after she and her husband ascended the English throne as joint monarchs.

This volume contained all the six hundred folios now at Windsor. During the three centuries that they remained within its covers, those executed in chalk suffered considerably from rubbing. To prevent further damage, most of the single-sided drawings were laid down on separate mounts in the nineteenth and early twentieth centuries. This technique could not however be applied to the anatomical series, most of whose folios bear drawings on both sides of the paper. The only solution was to rehouse them in new bindings, which exposed them to the same dangers as before. In recent years a new technique, which eliminates these dangers, has been devised. Each folio is encased within two thin panes of transparent plastic sheeting, and the resultant sandwich is inserted into a thick cardboard mount furnished with openings on both sides. Thus sheathed, a folio bearing a drawing on either side can not only be safely handled, but can also be placed on exhibition.

Before being mounted in this way the folios were examined and photographed under ultraviolet light, sometimes with remarkable results (see 3, 4, 5 A and B, 6A and B, 7).

A small selection of these drawings was exhibited in Washington and Los Angeles in 1976. The present much larger exhibition, which comprises about a quarter of the anatomical series, was shown in London in 1977 and later in Florence, Hamburg, Mexico City, Adelaide, and Melbourne. The entries for the catalogue were prepared by Kenneth Keele and Jane Roberts.

The entire series of anatomical drawings has been published in facsimile by Harcourt Brace Jovanovich, with a definitive catalogue by Kenneth Keele and Carlo Pedretti that includes a full transcription and translation into several modern languages of all the manuscript notes on the drawings.

ROBIN MACKWORTH-YOUNG
Librarian, Windsor Castle

INTRODUCTION

THESE ANATOMICAL DRAWINGS by Leonardo da Vinci from the Queen's collection at Windsor Castle have been selected and displayed as a synthesis of Leonardo's contributions to art and science in a field of endeavor that occupied him for a period of nearly thirty years, from about 1485 to 1510–15. The material is subdivided into nine groups according to a convenient subject-matter classification. This arrangement contributes to an even distribution of highlights in the visual impact produced by the beauty and precision of the drawings, but upon closer scrutiny it will soon become apparent that this material is best appreciated from the viewpoint of chronology, which gives the element of time perspective in the unfolding of Leonardo's thought. It is indeed this arrangement, or approach, that characterizes the facsimile edition of the total collection of Leonardo's anatomical studies at Windsor. It is quite appropriate, then, that this exhibition should open with an introductory section of two drawings only—one early and one late—showing an extraordinary progress in anatomical knowledge as Leonardo moves from traditional sources of learning, namely Mondino, to combine them with knowledge acquired through dissection, thus giving vividness and intensity to his vision of the human body as a machine.

Much of what has become famous of Leonardo's involvement with technology—his extraordinary way of presenting the operating power of a machine—comes to be projected into these images of the human body, in which one may even detect the same pulsating effect that Vasari said was to be perceived in the throat of Mona Lisa.

Leonardo's training as an artist in the Florentine studios of the late quattrocento coincides with an emerging concern for the representation of the human figure in action. With the Pollaiuolos it was not only the matter of assembling a vocabulary of gestures and attitudes, but also of introducing a new sense of vitality in the line of their drawings, the quick and lively notation of movement replacing the slow, careful definition of form: a quality of line that appeals to Leonardo as early as 1473, when he first discovers how light affects the vision of rocks, and trees, and waters, and fields, as he draws a landscape of the Arno valley that is a prefiguration of his later approach to natural forms in terms of structure and of a continuous flow of energy.

Leonardo's first codification of this new approach to natural forms and to the human figure comes with his Vatican *St. Jerome,* the unfinished painting that dates from the time of the *Adoration of the Magi,* about 1480. This is often mentioned as evidence of an anatomical knowledge based on dissection. It is indeed amazing how the muscles of the neck and shoulders should be so brilliantly displayed as to bear comparison with the most skillful analysis of the same muscles thirty years later, in the drawings of about 1510 shown in this exhibition (e.g., 27A and B). But the *St. Jerome* is above all the first document of Leonardo's principle of representing the human figure "in context," as if architecturally conceived in ground plan and elevation so as to enhance its volumetric presence in relation to its setting. This explains the extraordinary vitality

8

of all the paintings he was to produce later, when, for instance, the grotto of the *Virgin of the Rocks* was to be made so intimately related to the character of the figures it envelops as to be immediately felt as an integral part of the iconographic program and not to be taken simply as a decorative backdrop. Whenever, in fact, the human figure is presented as the nucleus of a natural setting, the equation between the figure and the generative forces of nature is implied. Hence the parallel that can be drawn between the celebrated drawing of a child in the womb and a human figure surrounded by an enveloping landscape, as in the *Mona Lisa,* in *Leda,* and in the *Virgin and Child with St. Anne.* And since generation is also transformation, the link is soon established with the stereometric principles in the architecture of the High Renaissance, when Bramante would conceive of a building as the nucleus of an enveloping architectural setting.

Leonardo and Bramante were friends. Little is known of the interaction of their ideas, the outcome of which, however, is that period of grandeur and monumentality in Italian art that is rightly viewed as a revival of the ideals of antiquity. It is an expression of intellectual clarity and power that reflects the imperial ambitions of popes and monarchs and the civic pride that was the basis of the socially reorganized Florentine Republic. The splendor and majesty of forms, both human and architectural, postulated by the artistic principles of Leonardo and Bramante were to lead inevitably to the academic art inherent in Raphael's response to those principles. And with this came the anxiety of an age of reforms that Michelangelo was best to express with his concept of the human body in attitudes of struggle.

CARLO PEDRETTI

9

LEONARDO DA VINCI THE ANATOMIST

To SAY THAT LEONARDO DA VINCI was a unique genetic mutation is perhaps only to put into modern language Vasari's sixteenth-century verdict that "his genius was the gift of God." But this gift or mutation was expressed not only in his intellect, but in his physique also. Moreover, Leonardo's approach to the anatomy of the human body was significantly influenced by his own remarkable physical attributes. According to Vasari, he combined in himself exquisite sensory sensitivity with great physical strength and dexterity, if we may use this term for a man whose writing and drawings throughout his life were left handed. And it happens that his work in anatomy falls into two clear-cut periods of his life that correspond to those sensory and motor attributes of his nature.

Leonardo's remarkable genetic endowments were derived from a peasant girl, Caterina, and a Florentine notary, Ser Piero da Vinci. Their bastard son, Leonardo, was born at Vinci on 15 April 1452. From a very early age he is said to have shown exceptional ability in geometry, music, and artistic expression. Ser Piero, noticing this, took his son's drawings to his friend Andrea del Verrocchio in Florence. Verrocchio was so struck by their quality that he accepted the promising young man straight away into his workshop. Verrocchio himself was well aware of the importance of perspective in art as well as the potential enrichment to art of representing the human body by a knowledge of anatomy. Like Leonardo he was an unlettered man, unimpeded by traditional learning from personal observation and the practical application of his ideas.

In a neighboring *bottega* the brothers Antonio and Piero del Pollaiuolo were similarly anatomically minded, using their knowledge as a basis for such pictures as the *Martyrdom of St. Sebastian* (London, National Gallery). Such a background provided Leonardo with an ideal point of departure for his own painting of *St. Jerome* (Rome, Vatican Museum), in which the anatomy of the head and neck so dramatically portrays the agony of his soul.

Perspective, however, was a less congenial subject to Verrocchio, who was daunted by its geometrical requirements. Not so Leonardo, who forged ahead in this field, basing his studies on the work of Leon Battista Alberti and Piero della Francesca. From experimental observations of objects through a vertical glass pane, or *pariete,* Leonardo came to appreciate the relation between perspective and the quantitative or measured observation of external bodies in their true proportions. This realization led him to apply himself to the objective representation of machines with such a degree of measurable accuracy that they have been reconstructed in recent years. It soon occurred to Leonardo that the same perspectival principle could be applied to extract "true knowledge" from the "universal machine of the earth." And what applied to the macrocosm of the earth applied also to that microcosm, the living body of man, which like the great "terrestrial machine" is "enclosed in the sphere of air."

Thus Leonardo's early explorations into human anatomy focused on the nature of "experience," and in particular of perspectival experience. It is mainly in these early years, about 1490,

that we find his many diatribes against the "authorities." For instance: "Many will think that they can with reason blame me, alleging that my proofs are contrary to the authority of certain men held in great reverence by their unexperienced judgments, not considering that my works are the issue of simple and plain experience which is the true mistress" (Codex Atlanticus, f.119va). This was written in those very same years during which he was carrying out diligent and painstaking experiments on perspective as well as his first anatomical dissections.

In this first period of Leonardo's anatomical studies, from about 1487 to 1493, it is interesting to observe how dissections of the sensory nervous system, particularly those parts concerned with vision, predominate. This assertion is only apparently contradicted by the fact that the finest drawings of the skull that he ever made were drawn at this time. One notices, however, that the text alongside these early drawings of the skull (as, for example, 8A) is largely devoted to the location of the center of the senses and vision within the skull. Here the system of crossing lines is mainly devoted to demonstrating the site of "the confluence of all the senses," that is, the *senso commune,* in which he locates the soul. And in the lower drawing on the same page the optic nerves find clear and isolated representation. Again, on the verso of this folio (8B), alongside his marvelous exposure of the orbit and maxillary sinus, he writes: "The eye, the instrument of vision, is hidden in the cavity above The hole *b* [the optic foramen] is where the visual power passes to the *senso commune.*" It was thus that he gave anatomical reality to his description of the eye as "the window of the soul."

This preoccupation with the physiology of vision even in such an unlikely anatomical context betrays the fact that the majority of Leonardo's many studies of the eye and vision are not to be found in his so-called anatomical manuscripts, but are scattered about elsewhere. All of them, however, are aimed at a deeper understanding of the nature of the subjective side of "experience" as obtained from all the senses, not only the eye. In parallel with this he was attempting to analyze the nature of the objective observation of natural phenomena, such as the shape, size, and distance of objects, using the technique of perspectival proportions on the vertical glass pane. Through the combination of perspective and physiology of vision Leonardo hoped to understand how "the mind of the painter must of necessity be transformed into nature's mind in order to act as an interpreter between nature and art" (Treatise on Painting, f.24v). Thus did Leonardo bridge the chasm between science and art.

After he felt that he had achieved an understanding of how "experience" could act as an interpreter between nature and art, Leonardo abandoned his anatomical investigations for nearly twenty years. During these years he was developing his science of the macrocosm of the world, which he called the "terrestrial machine." Finding simple linear perspective inadequate for solving distance problems, he extrapolated the principle of perspective to color and aerial perspective. He also formed the view that similar perspectival rules could be further extended in nature to the realm of what he called "the four powers of nature": movement, weight, force, and percussion, acting on the four elements of earth, air, fire, and water. All power, because it did not occupy space, he saw as "spiritual" forms of energy, manifested in movement or change. Having performed innumerable experiments with pulleys, levers, mirrors, lenses, and particularly with water, he came to the conclusion that these powers obeyed a perspectival or "pyramidal" form of action ("All the powers of nature have to be called pyramidal." Codex Atlanticus, f.151r-a).

At first Leonardo applied his rules of mechanics to the movements of man's body as a whole—to his center of gravity, to the actions of walking, running, and swimming. Many such studies are to be found in his Treatise on Painting.

About 1495 Leonardo became friendly with the mathematician Luca Pacioli, who propounded to him the works of such classical masters of mathematics as Euclid and Archimedes. This turned Leonardo's interest even more strongly toward the conviction that geometry held the key to the interpretation of nature; and this included the effects of the "four powers" within the body of man and of animals.

The opportunity to pursue anatomy further seems to have occurred by chance during one of Leonardo's visits to the hospital of Santa Maria Nuova in Florence. He tells how

> an old man a few hours before his death told me that he had passed a hundred years, and that he did not feel any bodily deficiency other than weakness. And thus while sitting on a bed in the hospital of Santa Maria Nuova in Florence, without any movement or sign of distress he passed away from this life. And I made an anatomy of him in order to see the cause of so sweet a death....This anatomy I described very diligently and with great ease because of the absence of fat and humors which much impede knowledge of the parts (R.L. 19027V).

In the performance of anatomical dissection Leonardo experienced the satisfaction of putting both his artistic and scientific principles into practice. Consumed as he was by curiosity and a passion for investigation, he was never one who believed in science for science's sake. At the end of one of his paeans in praise of science he concludes abruptly with the verdict: "From it [science] is born creative action, which is of much more value." And among his anatomical notes he comments: "This generation deserves unmeasured praises for the usefulness of the things they have invented for the use of man: and would deserve them even more if they had not invented noxious things like poisons and other similar things that destroy life or the mind" (R.L. 19045V).

Thus when Leonardo returned to anatomical investigation he put into practice all the scientific knowledge acquired since his earlier studies some twenty years before. This time the focus of his attention was centered on the movements in man's body. He sums up his outlook well on R.L. 19060R, alongside a drawing of the maternal and fetal circulations:

> Why nature cannot give movement to animals without mechanical instruments is demonstrated by me in this book on the actions of movement made by nature in animals. For this reason I have composed the rules of the four powers of nature, without which nothing through her can give local motion to these animals; and how this movement engenders, and is engendered by, each of the other three powers.... We shall begin by stating that every insentient local movement is generated by a sentient mover, just as in a clock the counterpoise is raised up by man, who is its mover.

Again, right in the middle of some beautiful drawings of the anatomy of the hand, on 32B, Leonardo suddenly breaks out with the injunction: "Make the book on the elements and practice of mechanics precede the demonstration of the movement and force of man and other animals, by means of which you will be able to prove all your propositions."

Leonardo's anatomical drawings can be looked at and enjoyed by many different kinds

of eye. For example, the eye of the artist will see in them the skill of his perspectival reduction of a three-dimensional object into a two-dimensional representation and the delicate hatchings of light and shade giving birth to the illusion of relief. The scientific eye will appreciate the three-dimensional accuracy of what he portrays: his insistence on the demonstration of all parts from at least three aspects, from in front, behind, and the side. To this he added his uncanny power of illustrating the mechanics of the movement of joints and muscles.

Leonardo himself gave most diligent attention to developing his technique of anatomical illustration. One of many such passages (abbreviated) runs:

> This plan of mine of the human body will be unfolded to you just as though you had the natural man before you. The reason is that if you wish to know thoroughly the parts of man after he has been dissected you must either turn him, or your eye, so that you examine him from different aspects, from below, above, and from the sides.... But you must understand that such knowledge as this will not continually satisfy you on account of the very great confusion that must arise from the mixture of membranes with veins, arteries, nerves, tendons, muscles, bones, and the blood that itself tinges every part with the same color.... Therefore it becomes necessary to have several dissections: you will need three in order to have a complete knowledge of the veins and arteries: three others for a knowledge of the membranes: three for the nerves, muscles, and ligaments; three for the bones and cartilages, and three for anatomy of the bones, for these have to be sawn through in order to show which are hollow and which not.... Three also must be devoted to the female body, and in this there is great mystery by reason of the womb and its fetus... (R.L. 19061R).

There is good reason to believe that Leonardo in fact carried out a great part, if not all, of this plan, for late in life he mentioned that he had dissected more than thirty bodies, and it is known that a number of small notebooks *(libretti)* offered to and refused by the grand duke Cosimo II de Medici in Florence in 1613 have since been lost.

For particular anatomical problems Leonardo devised ingenious solutions. For example, in order to clarify the action of joints as fulcra for movements of the bones, he separated their surfaces. "Thus you will give true knowledge of their shapes, knowledge that is impossible for either ancient or modern writers without an infinitely tedious example and confused prolixity of writing and time" (20A). When confronted with the problem of demonstrating the relations of muscles on different planes he advocates: "Before you form the muscles make in their place threads that should demonstrate the positions of these muscles; the ends of these [threads] should terminate at the center of the attachments of the muscles to the bones" (27B and R.L. 19017R). Thus he reduced bones and joints to levers acting on fulcra, and muscles to lines of force acting on these levers. When wishing to reveal the true shape of the ventricles of the brain, Leonardo utilized his skill in sculpture, making wax casts of them by injection, and then removing the surrounding brain tissue (10). When wishing to observe the movements of blood as it streamed out through the aortic valve of the heart, he made a glass cast of the part (38).

In summary, Leonardo's anatomical drawings were of three main types: those derived from his medieval predecessors, drawings of "descriptive anatomy" from untrammeled observation, and drawings illustrating his own physical laws applied to the human body.

13

Anatomy in medieval times was very crude. Primitive squatting figures containing almost unrecognizable organs meant to be read symbolically, not as true representations, were standard works used by doctors. Some of Leonardo's early anatomical drawings of about 1489 were founded on this medieval anatomy. For example, the drawing of the three cerebral ventricles (9A) represents them according to the pattern found in *The Philosophy of Albertus Magnus,* a copy of which Leonardo possessed. From another medieval work, *Ketham's Fasciculus of Medicine,* Leonardo borrowed the outline of the human figure into which he inserted his own visualization of the "tree of the vessels" based upon the concept of Galen (1). In this same period he was making purely descriptive anatomical illustrations based on his own observations and made possible by his mastery of perspective. Such were those of the skull on R.L. 19058v, where for the first time the maxillary sinus in the cheekbone is demonstrated. This kind of illustration, based on direct dissection, was quite unprecedented.

By the eventual application of his physical laws to human anatomy, Leonardo achieved a wholly unique penetration into the mechanical principles of physiology. His contemporaries were quite unready for this. Indeed, descriptive anatomy itself did not come to the surface until Galenic anatomy was undermined by the successful revolutionary efforts of Vesalius in his magnificently produced work, *De Humani Corporis Fabrica,* published in 1543, twenty-four years after Leonardo's death. This was the work for which contemporary anatomists were ready; this was the work that historically opened the floodgates of future anatomical progress. Thus in anatomy, as in so many other aspects of his life's work, Leonardo was a man who awoke too early in the dawn of the scientific Renaissance while others still slept.

Leonardo unconsciously described himself and his own particular genius for anatomy in the following passage (R.L. 19070V):

> You who say that it is better to look at an anatomical demonstration than to see these drawings would be right, if it were possible to observe all the details shown in these drawings in a single figure, in which with all your ability you will not see, nor acquire knowledge of more than a few vessels.... And as one single body did not suffice for sufficiently long a time it was necessary to proceed by stages with as many bodies as would render my knowledge complete: and this I repeated twice in order to discover the differences.
>
> But though possessed of an interest in the subject you may perhaps be deterred by natural repugnance, or if this does not restrain you then perhaps by the fear of passing the night hours in the company of these corpses, quartered and flayed, and horrible to behold. And if this does not deter you, then perhaps you may lack the skill in drawing essential for such representation, and even if you possess this skill it may not be combined with a knowledge of perspective, while if it is so combined you may not be versed in the methods of geometrical demonstration, or the methods of estimating the forces and power of the muscles; or you may perhaps be found wanting in patience so that you will not be diligent.
>
> Concerning which things, whether or no they have all been found in me, the hundred and twenty books which I have composed will give their verdict, yes or no. In these I have not been hindered either by avarice or negligence, but only by want of time. Farewell.

KENNETH D. KEELE

14

COLORPLATES

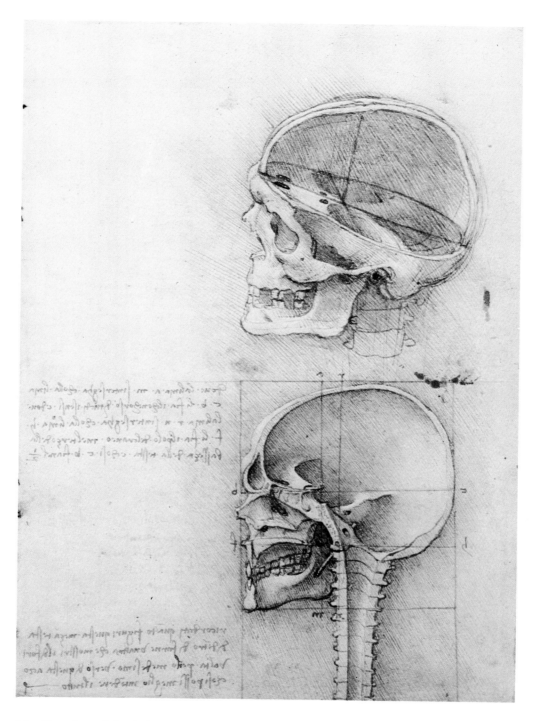

8A. *Two views of the skull* (R.L. 19057R)

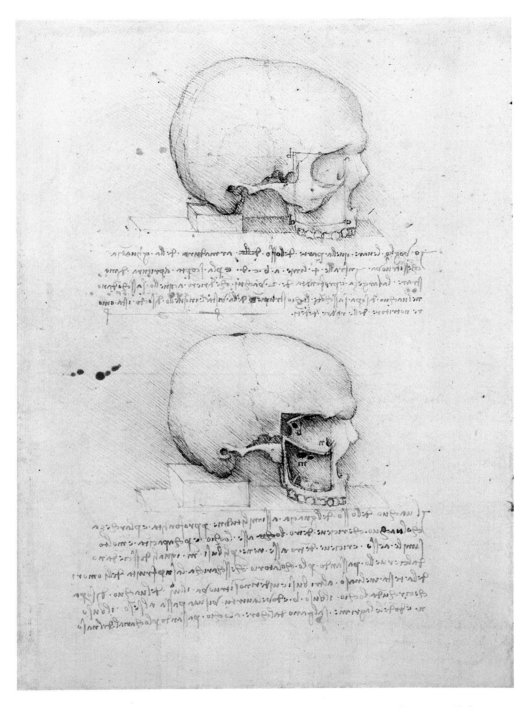

8B. *Two views of the skull dissected to show the cavities of the orbit and maxillary sinus* (R.L. 19057v)

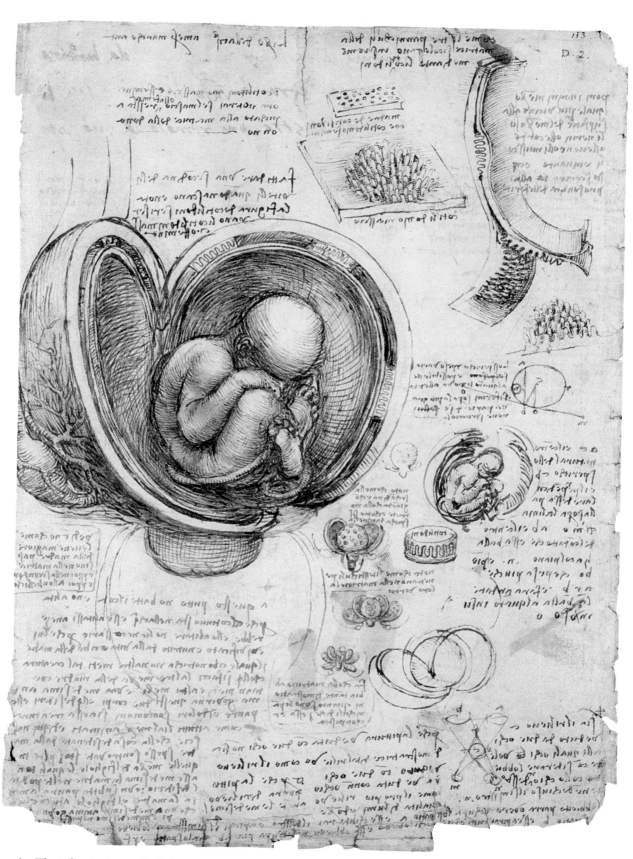

19A. *The infant in the womb* (R.L. 19102R)

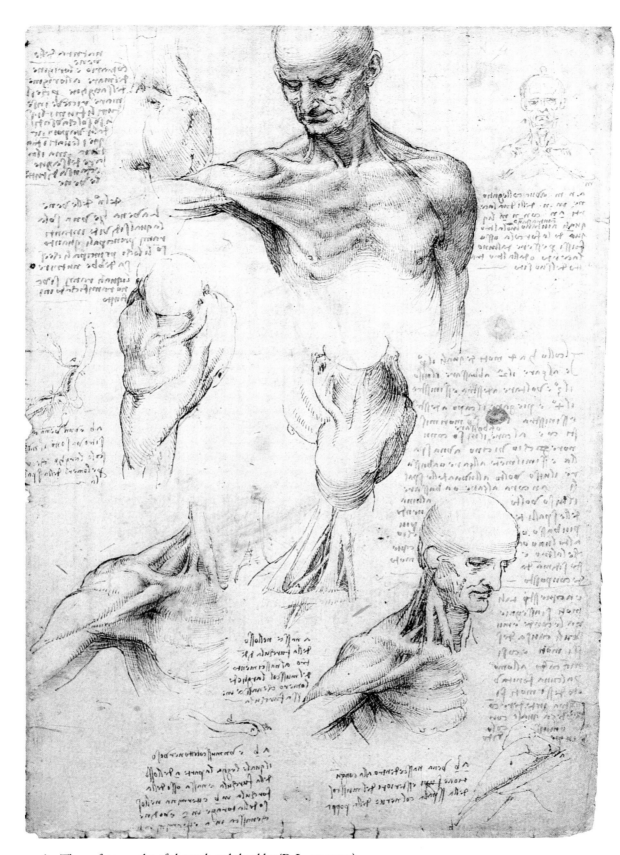

27A. *The surface muscles of the neck and shoulder* (R.L. 19003R)

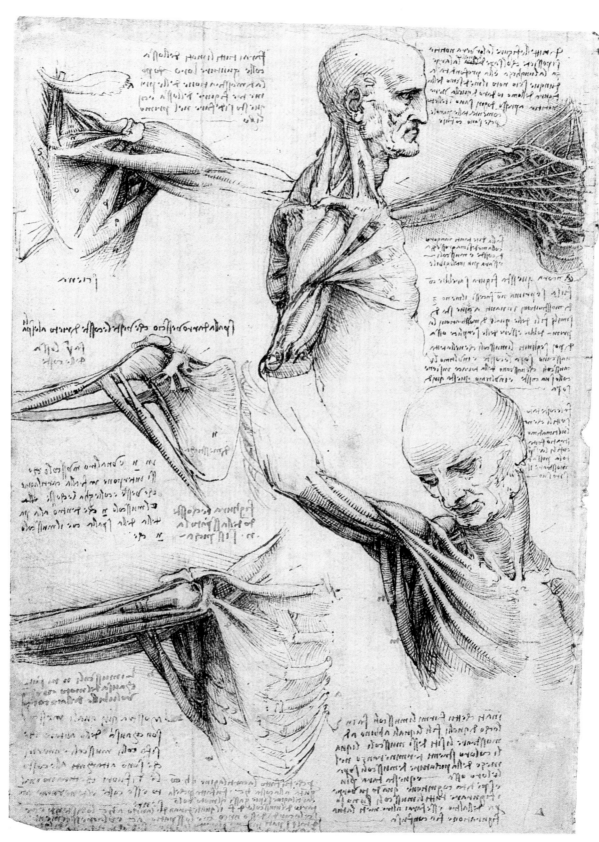

27B. *The muscles of the shoulder* (R.L. 19003v)

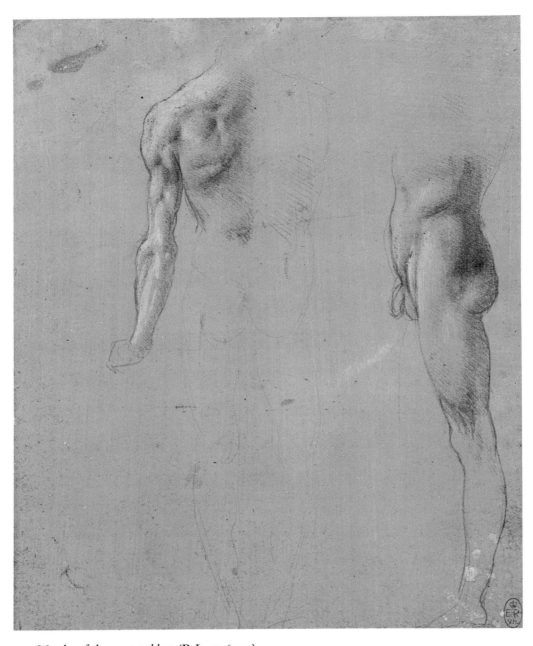

47. *Muscles of the arms and legs* (R.L. 12637R)

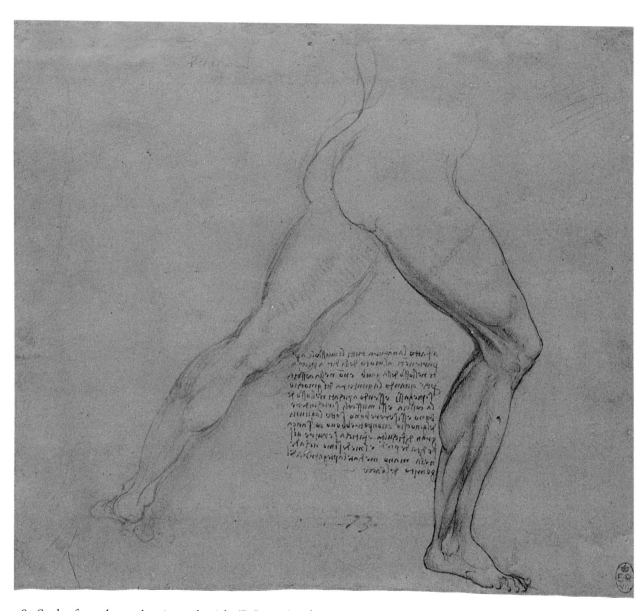

48. *Study of a nude man lunging to the right* (R.L. 12623R)

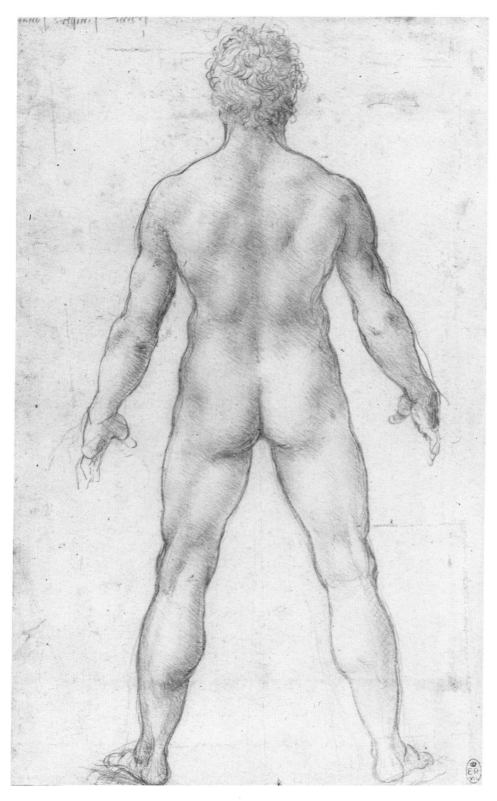

50. *Male nude seen from the back* (R.L. 12596R)

24

CATALOGUE OF DRAWINGS

Measurements are given in millimeters, height preceding width. The drawings are on white paper unless otherwise indicated. The catalogue has been arranged in roughly chronological sections, except for the last three, which act as an appendix to the theme of Leonardo's anatomical studies.

THE INTERNAL ORGANS

A PERIOD of about ten years separates the two drawings shown here (1 and 2). During these decades, which span the turn of the fifteenth century, Leonardo bridged the gap between medieval and modern anatomy. But he did not achieve this feat all at once.

The advances made can be seen here in the greater accuracy in the location and shape of the liver, kidneys, and spleen demonstrated in the later drawing.

The rather unhappy-looking man drawn in 1, in which Leonardo has retained a considerable amount of medieval anatomy, is taken from a medieval fasciculus of medicine.

1. Anatomical figure showing heart, lungs, and main arteries

Pen and dark brown ink with colored washes over black chalk. 280 × 198 mm (R.L. 12597R)

This sheet is headed, between the legs of the figure: *albero dj uene* (tree of the vessels), and to the left, *parte spiritualj* (spiritual parts), relating to the Galenical vascular system, according to which the natural spirits were carried by veins from the liver and vital spirits by arteries from the heart. Below this is a reminder to "cut through the middle of the heart, liver, and lung and the kidneys so that you can represent the vascular tree in its entirety."

The degree of anatomical inexactitude together with the ornamental handwriting suggest a date in the 1490s for this drawing, which relates to the ancient and medieval anatomical knowledge of Leonardo's predecessors. It is possible that it is connected to an anatomical model, for it is close in date to 16B, on which Leonardo makes a reference to the construction of such a model: "When you have finished making the man, you will make the statue with all its superficial measurements."

2. Dissection of the principal organs and arterial system of a woman

Pen and ink wash over black chalk on color-washed paper. Pricked through. 478 × 333 mm (R.L. 12281R)

This study dates from some ten years later than 1. While showing much progress in correcting some of the inaccuracies of the earlier drawing, it retains many of the errors Leonardo inherited from Galen and Avicenna. An example of this is the depiction of the vena cava passing the heart and giving a branch to the right ventricle, with no atrium at all. Original observation is shown in the relative accuracy of shape and size of the kidneys, liver, and spleen, which were studied in detail in the pages of Folio B.

In the manuscript passage in the top left-hand corner Leonardo makes one of his many notes on further drawings to be done from his dissections: "Make this demonstration also seen from the side, that knowledge may be given how much one part may be behind the other, and then make one from behind, that knowledge may be given of the veins possessed by the spine, and by the heart, and greater veins."

The manner of pricking through and folding of this sheet suggest that the main shape of the left-hand side of the page was drawn on first, the sheet folded vertically and pricked through, and that the right-hand side was drawn on the basis of these pinpricks. When the figure had been completed, and the asymmetrical features added, the whole figure was again pinpricked, this time for transfer to another sheet (R.L. 12280).

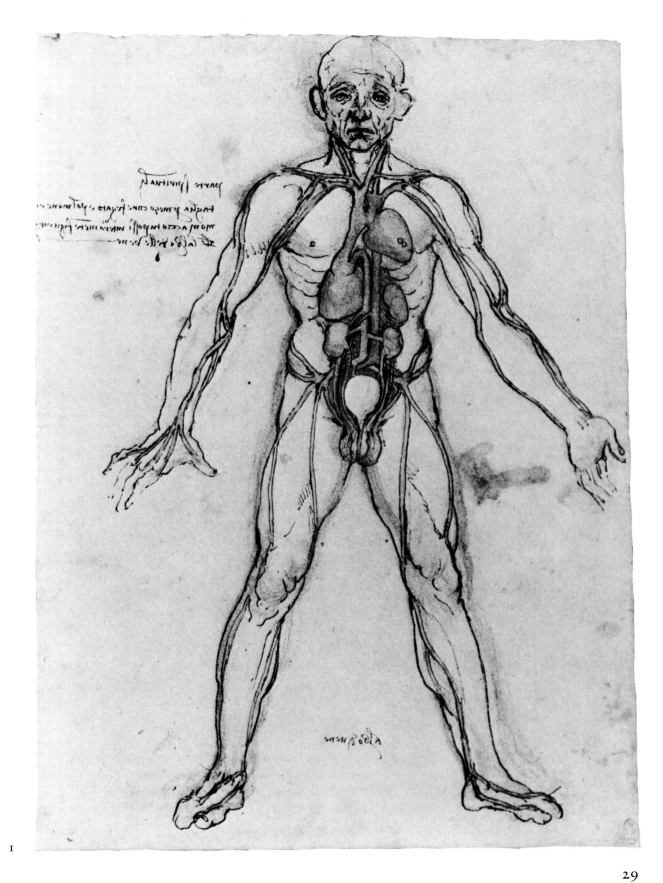

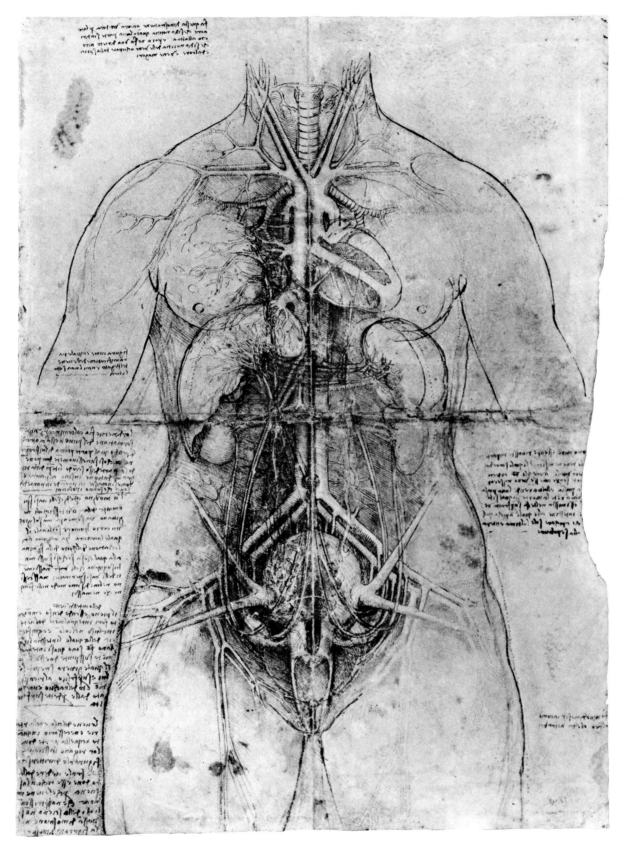

2

EARLY ANATOMICAL STUDIES

THIS SECTION consists of five sheets of metalpoint studies on blue prepared paper, some of which (e.g., 5A) are labeled with double letters in a sixteenth-century hand. They clearly date from the same chronological period (about 1487–89), and the drawings on them are closely similar in content.

The studies are mainly anatomical and show a combination of traditional views (particularly with reference to the brain) and the artist's own experimental anatomy, involving dissection in one case of a frog (5B), in another of a monkey (5A), and in others of a man. These drawings are sometimes accompanied by Leonardo's records of his anatomical methods, in which he mentions what he has already done and what he has still to do. He is concerned in particular with problems regarding the nervous system.

Our reading of these sheets has been greatly assisted by their examination under ultraviolet light. Whatever the substance of the metalpoint Leonardo used (it has always in the past been called silver), it must have faded from normal vision very soon after these drawings were made. Confirmation of this is found in Dürer's copies of drawings on 5B in his Dresden sketchbook, in which he drew only as much as is visible today, and not the complete metalpoint drawings, which are visible only under ultraviolet light.

3 Miscellaneous anatomical drawings

Pen and dark brown ink (two shades) over metalpoint on blue prepared paper. 222 × 290 mm (R.L. 12627R)

The drawing bottom center shows Leonardo's attempts to acquaint himself with the general positions of the main viscera (labeled with indicator lines) in the chest and abdomen—what was known as a "situs figure" in his day. To the left of this, in an oval section, is an attempt at cerebral localization in the ventricles of the brain; the optic, olfactory, and acoustic nerves being traced back to their hypothetical destinations. Under ultraviolet light the ventricles of this diagram can be seen to be marked, from top to bottom: *memoria, chomune senso* (i.e., *senso commune*), and *imprensiva.* The three ventricles are drawn again within the skull in the old man's head to the left. Another drawing of the skull, apparently connected with the old man's head on the left margin, is clarified under ultraviolet light immediately to the left of the situs figure. It shows the orbits from which the optic nerves issue, converging on the anterior ventricle. This is connected by a narrow channel to the middle and posterior ventricles. For the diagrammatic treatment of the cerebral ventricles, see entry for 9A, of 1493–94.

To the right, upside down, is a dissection of the leg, showing the saphenous nerve and its accompanying vein, with the straplike sartorius muscle labeled *lacerto.*

The rough sketch in the center represents visceral organs of an animal. It

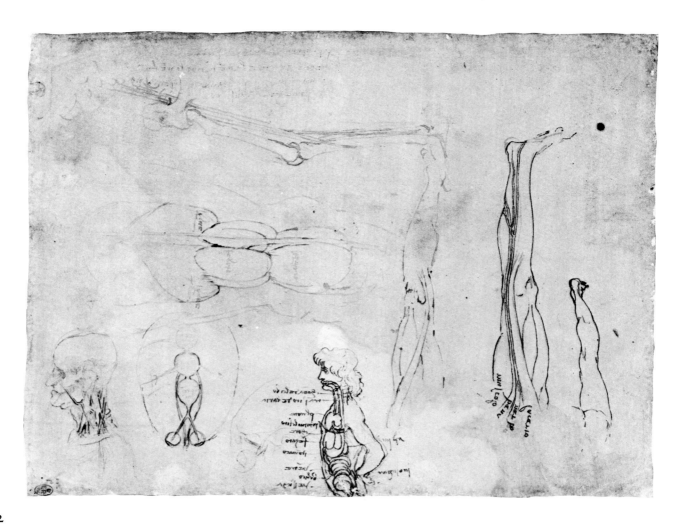

is labeled, from right to left, *stomacho* (stomach), *fegato* (liver), and *sangue* (blood), the latter indicating what appear to be two pleural cavities containing blood.

Along the top of the sheet is a sketch of the lumbar spine, pelvis, femur, and tibia, drawn to show the relation of the bones to the origins and course of the sciatic nerve. The femur with its trochanter tertius, laterally, shows that Leonardo had some knowledge of the skeleton of the horse at this time.

Several other totally new drawings appear under ultraviolet light. In the top right-hand corner are two sketches for a system of gear wheels and pinions for augmenting lifting power. To the left of these is Leonardo's familiar doodle *djmmj* (tell me), and below there is a sketch of nerves emerging from beneath the clavicle into the arm (compare 5A). To the right of the situs figure, bottom right, is a small interlacing pattern. Beneath the old man's head on the left-hand margin is a rectangular structure: perhaps the ground plan of some architectural project. Below the sketch of the viscera in the center, facing toward the top of the sheet, a youthful profile has appeared. In addition, four enigmatic lines of script are revealed (top left), presented in the form of a riddle which has not yet been solved by Leonardo scholars.

3 ULTRAVIOLET

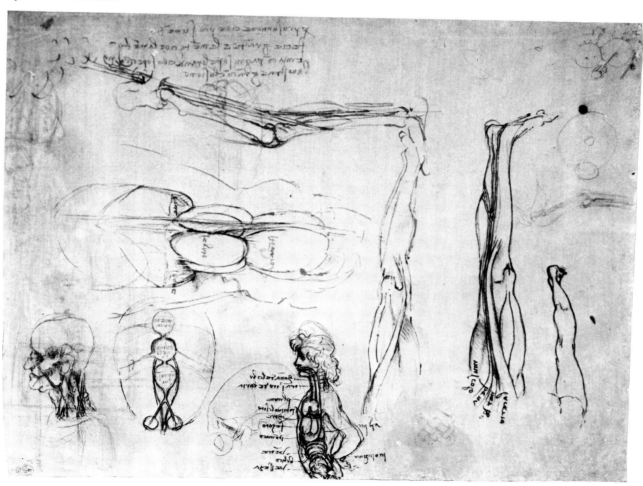

4. Muscles, tendons, and veins of the arms and legs

Pen and brown ink (two shades) over two types of metalpoint on blue prepared paper. 212 × 297 mm (R.L. 12617R)

The sheet contains eight drawings of a man's leg, including one segmental view (to left of center) and below this a sectional view of the lower leg, lettered *a–o*. To left and right, on the lower part of the sheet (turn the paper 90 degrees), are two studies of the arm and shoulder, showing very elementary patterns of the brachial plexus. To the right of center is a rough sketch of the abdominal muscles, with ribs and pelvis. All these forms are greatly clarified by ultraviolet light, as are the architectural plans along the lower edge of the sheet. Their purpose is still unknown, but they may refer to plans of palaces as shown in Codex Atlanticus, f.324r of about 1482, on which Leonardo listed the works that he was to take to Milan or leave in Florence. As one ground plan hints at columns and steps as in an antique temple, these architectural scribbles may be theoretical notations inspired by the reading of Vitruvius.

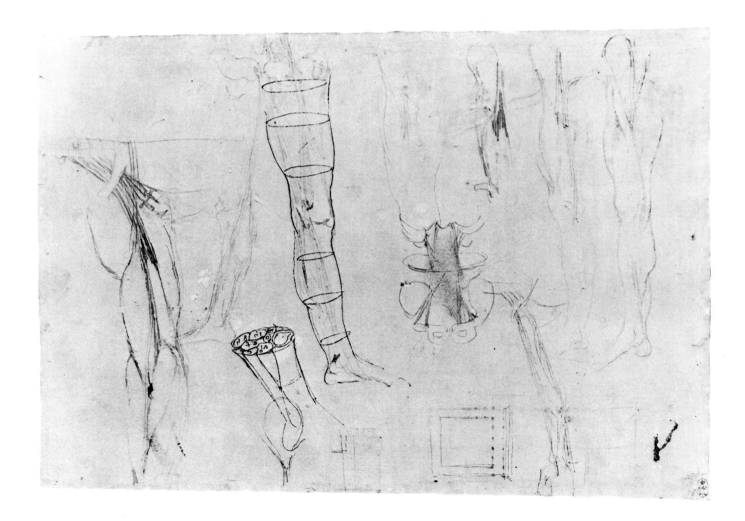

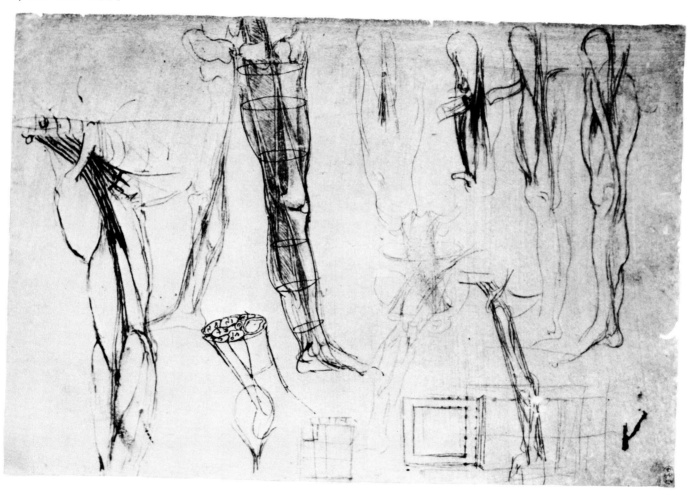

5A. *The bones and tendons of the arm and shoulder with studies of animal viscera*

Pen and dark brown ink over metalpoint on blue prepared paper. 222 × 304 mm (R.L. 12613R)

The drawings on this sheet are closely connected with those of 3: the views of animal viscera occupying most of the left-hand side of the sheet, and the faint studies of shoulders and the inverted leg at the right-hand edge are very similar to forms on that sheet. Once again, ultraviolet light has revealed a large number of these forms and clarifies various passages of the manuscript. That in the top right-hand corner, written from left to right, reads as follows:

> *Jn questo modo nascho*
> *no i nervi dj tutta la*
> *persona a ciaschu*
> *nodo de la schiena*

(In this manner originate the nerves of the whole person at each projection of the spine.) On the same subject a drawing of vertebrae, center left, invisible under ordinary light, is inscribed: *osso / spūga / nervo voto* (bone, sponge, empty nerve). This figure makes clear that the spinal nerve issues between two transverse processes of neighboring vertebrae. The term "empty nerve" refers to the concept of nerve impulses passing down a hollow ("empty") cavity along the length of the nerve.

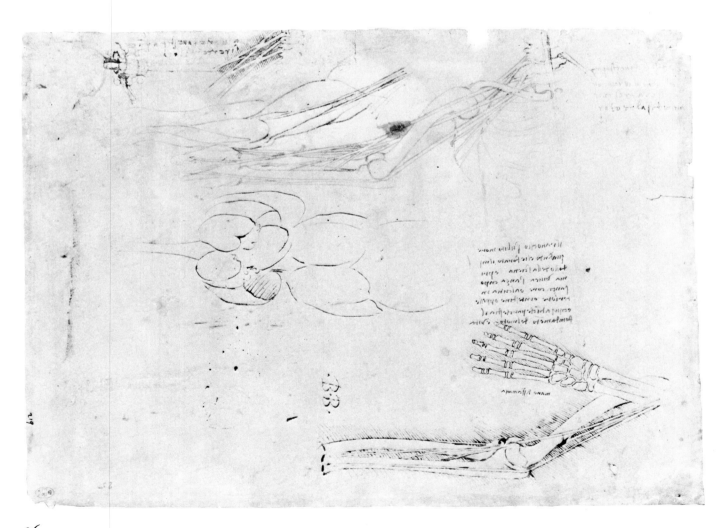

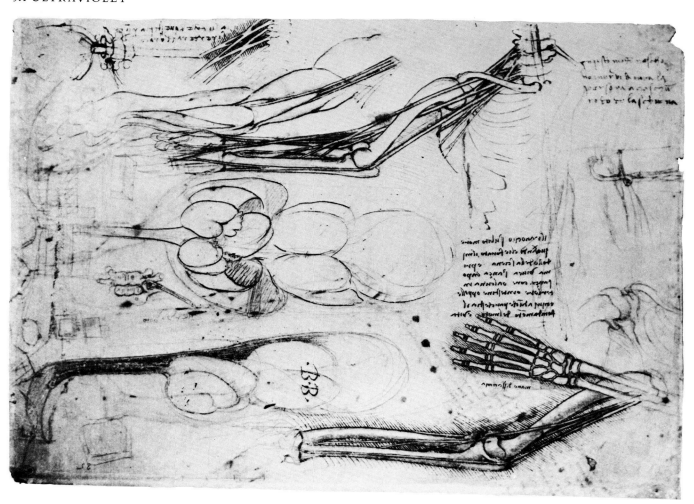

37

5B. *The skeleton and tendons of the arm and leg*

Pen and dark brown ink over metalpoint on blue prepared paper. (R.L. 12613v)

The main drawings covering the right-hand side of this sheet were copied (in reverse) by Dürer in his Dresden sketchbook. For various reasons it is unlikely that Dürer saw this sheet, and it is more likely that he had access to a copy (perhaps an engraving) after it. Whatever the case, he copied only as much of the drawings as are visible today: the incomplete drawing of the skeleton and tendons of the leg is incomplete in Dürer's copy, while ultraviolet light reveals that Leonardo had completed it in his metalpoint underdrawing. It seems therefore that the underdrawing had already faded from normal vision in Leonardo's lifetime. Other drawings that appear under ultraviolet light include a tower-like structure to left of center, comparable to one in the Codex Atlanticus.

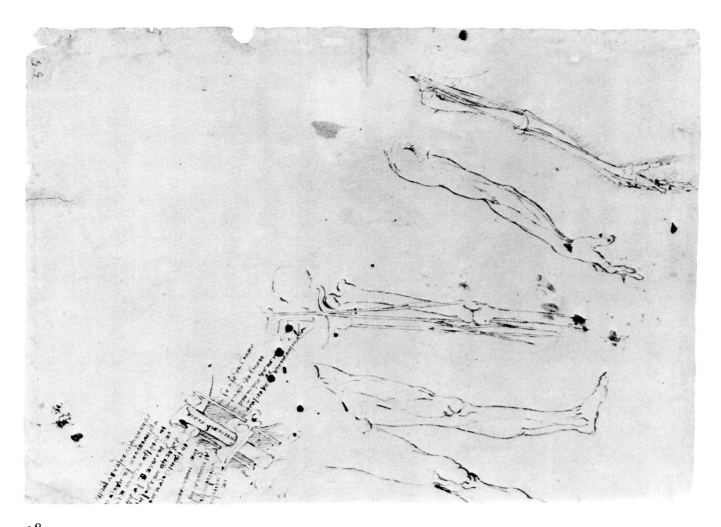

38

The drawing at left refers to the spinal cord of a frog. The annotations surrounding the drawing, written both left to right and right to left, include passages such as the following: "The frog instantly dies when its spinal cord is perforated. And formerly it lived without head, without heart, or any entrails or intestines or skin. It thus seems that here lies the fundamentum of motion and of life." Such words presuppose a program of study and experiment. The spinal cord is labeled "generative power," referring to the belief held by Hippocrates and other later authorities (including Avicenna) that "the most active and thickest part" of the semen comes from the spinal cord (see also 16A).

5B ULTRAVIOLET

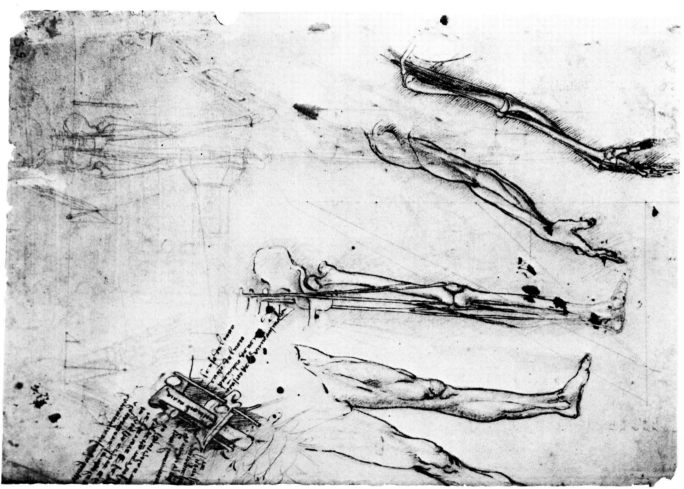

6A. *The skeleton, muscles, veins, and cartilage of the head and neck*

Pen and brown ink, heightened with white, over two types of metalpoint on blue prepared paper. 202 × 287 mm (R.L. 12609R)

Ultraviolet light reveals that not only the main figure on this sheet, but also the subsidiary one, middle right, are concerned in detail with the anatomy of the neck. The quickly sketched figure, bottom left, can now be identified as a diagram of the abdomen, and at the right of this form, along the lower edge of the sheet, are a grotesque head and a crouching figure.

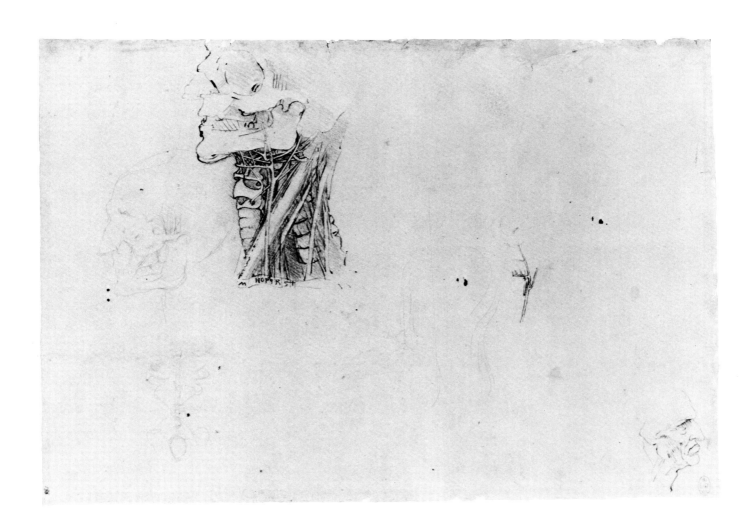

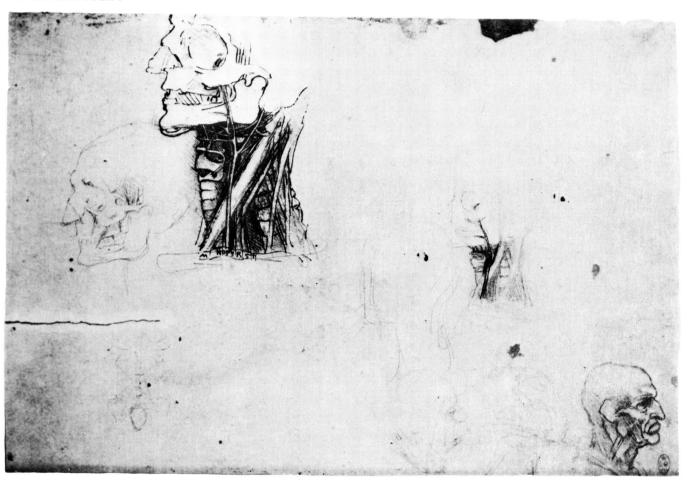

6B. *View of a church*

Pen and dark brown ink over
metalpoint on blue prepared paper.
(R.L. 12609v)

There are no anatomical drawings on this side of the sheet, but the architectural forms—so well clarified by ultraviolet light—are contemporary with the anatomical drawings of the series.

The main drawing appears to show a cross section of a model in which three of the arms of a centrally planned building, topped by a cupola, are shown, with conches, triforium gallery, and paneled dado on apsidal ground plans. The drawing is almost certainly related to the Romanesque church of San Sepolcro in Milan, which is referred to in other Leonardo manuscripts of this time. It is possible that the subsidiary sketch to left of center, revealed by ultraviolet light, indicates the actual structure of San Sepolcro, while the main study incorporates a restoration program inspired by Bramante.

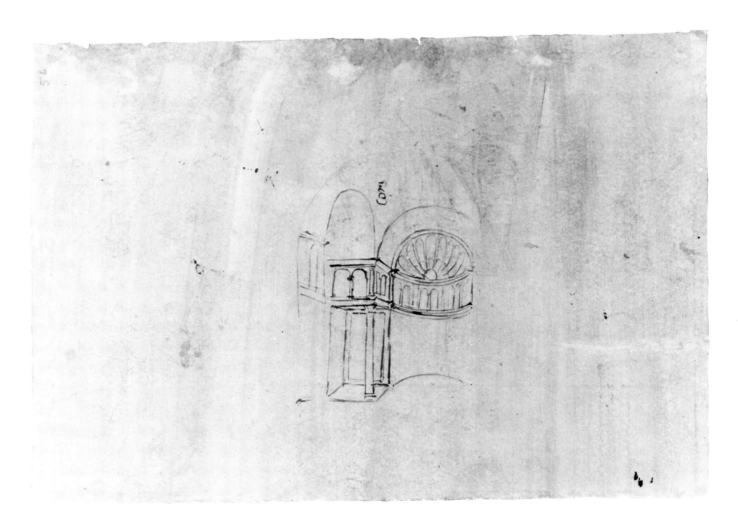

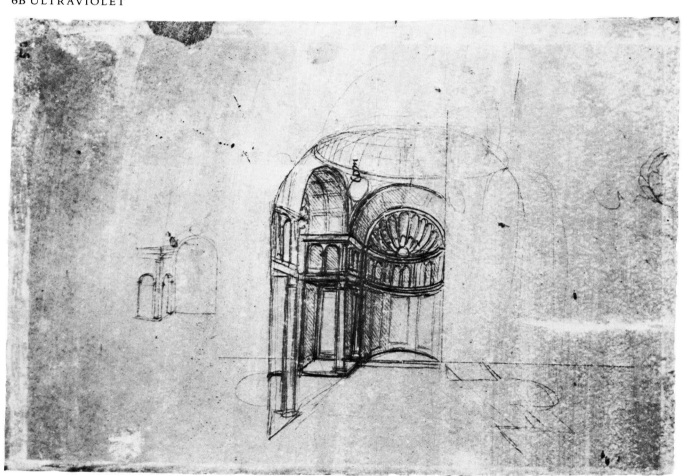

7. The musculature of the leg and the anatomy of the head and neck

Pen and brown ink (two shades) and metalpoint on blue prepared paper. 203 × 300 mm (R.L. 12626R)

The right-hand figure of the thigh and upper leg is annotated as follows: "I have removed the muscle a−n (sartorius), which has a length of half a braccio, and I have uncovered r−t. Now attend to what remains below m−o."

The drawings of the skull and neck continue Leonardo's inquiries seen in 6A and repeat the traditional figure of the cerebral ventricles as seen in 3 (and in 9A). The labeling of the ventricles is altered in 7. From top to bottom it is: *memoria* (memory), *senso commune* and *volōta (senso commune* and willpower), *imprēsiva* and *inteletto* (feeling of impressions and intellect).

The architectural sketch, bottom left, appears to be related to Battagio's Santa Maria della Croce at Crema, of about 1493. The main building is apparently placed on the shore of a lake and is connected by a bridge to a round platform on a promontory on the opposite shore.

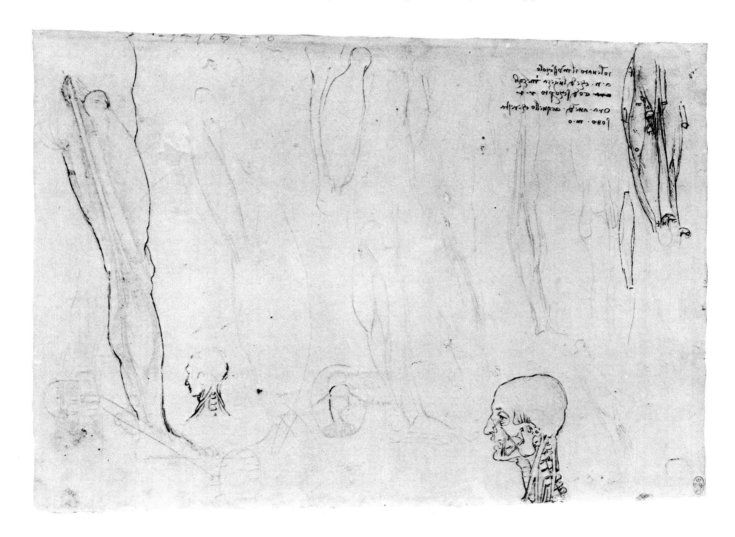

44

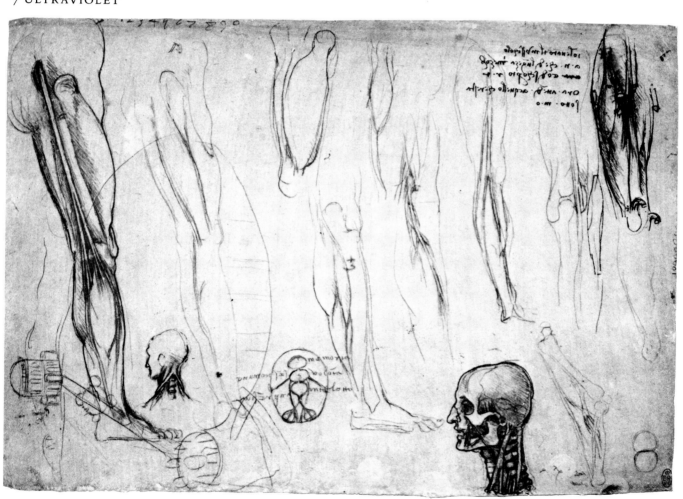

HEAD AND BRAIN

LEONARDO'S first fully worked anatomical studies were made on the head, about 1489. In these his prime objective appears to have been the location of the *senso commune,* the meeting place of all the senses and the seat of the soul, which is located on 8A in the region of the third ventricle of the brain. In the course of his dissections of the skull and brain, Leonardo made several discoveries, unknown before his time, such as the maxillary antrum (8B) and the frontal sinus (8A and 9A), and he illustrated the optic chiasma (11).

The superb drawings of the cranium made in 1489 (e.g., 8A and B) are apparently the only detailed studies of the skull made by Leonardo. He evidently considered that he had mastered the correct anatomical depiction of this area.

8A. *Two views of the skull*

Pen and brown ink (two shades) over
black chalk. 188 × 134 mm
(R.L. 19057R)

In these drawings of the human skull Leonardo exerted all his artistry in the perspectival creation of verisimilitude, as shown by the fine delicacy with which he represents variations in the contour of the skull bones in the upper drawing. The skull is shown from the side with the vault bisected in a medial sagittal section. In the lower figure the skull has been tilted forward and the section has been carried through the whole skull, so exposing the frontal and sphenoidal sinuses, the three cranial fossae, and the nasal cavity. It ends with an imaginative representation of the upper vertebrae.

The squares with crossing lines dividing up the lower figure are best described by Leonardo's own words to the left of the sheet: "Where the line $a-m$ is intersected by the line $c-b$ there the meeting place of all the senses [*senso commune*] is made, and where the line $r-n$ is intersected by the line $h-f$ there the fulcrum of the cranium is located, at one third from the base line of the head." In another place Leonardo states that "the *senso commune* is the seat of the soul," and we may therefore see in this figure his exact location of the soul in the body.

The drawings can be dated 1489 owing to the close relationship between content and style of this sheet and that of another sheet of drawings at Windsor (R.L. 19059R) inscribed with the date 2 April 1489.

The upper figure of the skull was engraved by Wenceslaus Hollar in 1645, when the drawing was in the collection of the Earl of Arundel.

8B. *Two views of the skull dissected to show the cavities of the orbit and maxillary sinus*

Pen and brown ink over black chalk.
(R.L. 19057V)

Below the upper drawing Leonardo writes: "I wish to lift off that part of the bone armor of the cheek, which is found between the four lines $a-b-c-d$ and through the exposed opening to demonstrate the width and depth of the two empty cavities that are concealed behind that [bone]." This exposure, illustrated in the lower drawing, shows the bony cavity of the orbit (marked d) "in which the instrument of vision is hidden."

The cavity below this is the maxillary antrum or sinus (marked m) which, as Leonardo puts it, "contains the humor that nourished the roots of the teeth." Until these drawings were first thoroughly studied in 1901 it was believed that the maxillary antrum had been discovered by the Englishman Nathaniel Highmore in 1651. In the notes below the lower drawing Leonardo records the position and nature of the vessels entering the two cavities. The lower cavity "receives veins into it through the holes m that descend from the brain passing through the sieve [cribriform plate of the ethmoid] that discharges the superfluous humors of the head into the nose. No other holes are evident in the cavity above which surrounds the eye. The hole b [optic foramen] is where the visual power passes to the *senso commune;* the hole n is the place from which the tears rise up from the heart to the eye, passing through the canal of the nose." This last passage is explicable by Leonardo's current belief that heat raised all fluids to the head.

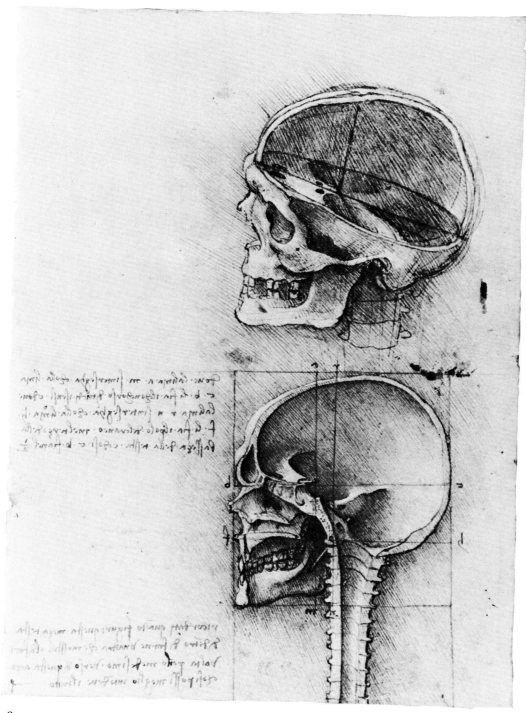

8A

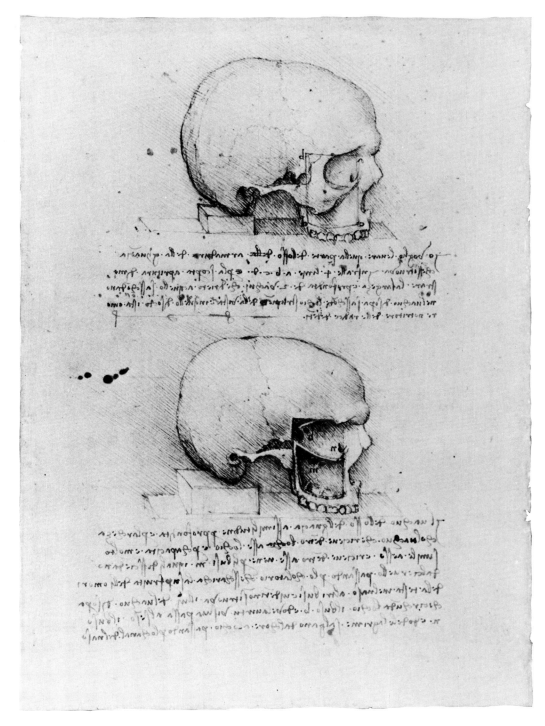

9A. The layers of the scalp compared with an onion

Pen and brown ink (two shades) and red chalk. 203 × 152 mm
(R.L. 12603R)

These early drawings are well described in Leonardo's own words along the left-hand edge: "If you will cut an onion through the middle you will be able to see and count all the cover or rinds which circularly clothed the center of this onion. Similarly, if you will cut through the head of a man in the middle, you will first cut the hairs, then the coating and the muscular flesh and the pericranium, then the cranium, and within, the dura mater, and the pia mater and the cerebrum, then again the pia and the dura mater and the rete mirabile and the fundamentum of that, the bone." These layers are labeled in the main figure and in the section bottom right.

Above the eye the frontal sinus is seen—which, with the superciliary arch, is given rather undue prominence by the artist (as in 8A and B). The frontal sinus was one of Leonardo's many anatomical discoveries.

From the similarly "onion-coated" eyeball the optic nerve runs to the cavity representing the anterior of the cerebral ventricles. Bottom right is a horizontal sectional diagram of the upper part of the skull, with the top part hinged backward. The shape and form of the ventricles in these figures are diagrammatic representations of the description of the brain given by the old anatomists. Leonardo reached a much closer approximation to their actual form in 10, over a decade later. The date of the drawings on the present sheet is about 1493-94.

9B. Perspective studies of the head

Pen and brown ink with oxidized white and traces of metalpoint
(R.L. 12603V)

It has often been claimed that the group of drawings on the lower half of this page represent studies of spectacles. In fact they are studies in perspective of the optic nerve and auditory nerves converging within the brain onto the *senso commune* and are therefore related to the drawings of the cerebral ventricles on the recto of the sheet.

At this time—that is in the years after 1490—Leonardo was attracted by the relationship between perspective, vision, and objective observation. The three miniature heads (bottom right) show an experiment in "transformation" whereby the projection of an anterior view can be used to construct views in perpendicular planes.

This page contains a number of metalpoint studies that are only legible when viewed under ultraviolet light. The inverted profile at bottom, right of center, has been gone over (not by Leonardo) in white lead, which has since oxidized.

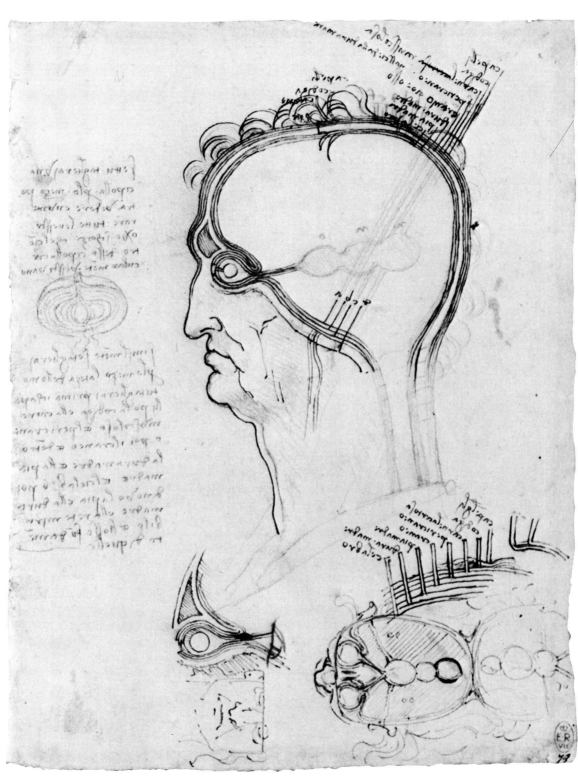

9A

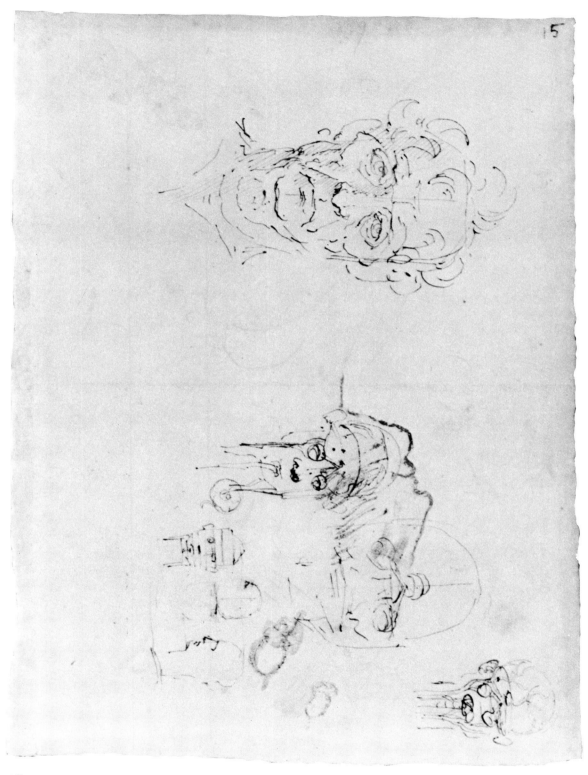

9B

10. *The brain injected to demonstrate the shape of the cerebral ventricles*

Pen and brown ink (two shades) with black chalk. 200 × 262 mm
(R.L. 19127R)

The injection of parts to discover their true form is among the most important innovations in anatomical technique contributed by Leonardo. Here he applies it to the anatomy of the cerebral ventricles. In the drawing top left the site of injection of melted wax is marked at the base of the third ventricle (here central, and labeled *senso commune*). The shape of the wax cast is seen in this and in the drawing to its right of the brain in horizontal section. It can be seen that the wax distorted the third ventricle and failed to fill the lateral ventricles completely, but it revealed the first resemblance to their true size, shape, and position and represents a marked advance on the diagrammatic layout of the ventricles in, e.g., 9A. The site of injection is again marked at the center of the rete mirabile in the bottom figure (identifying the brain as that of an ox).

The notes consist of detailed instructions of the technique of injection, which is again illustrated in the small sketch in the bottom right-hand corner. The drawings on this sheet are datable about 1508–9.

11. *The optic chiasma and cranial nerves*

Pen and brown ink (three shades) over traces of black chalk. 190 × 136 mm
(R.L. 19052R)

The drawing top left shows the eyeballs, optic nerves, and optic chiasma. Parallel to and above the optic nerves are the olfactory nerves, about which Leonardo makes the following brief statement at the top of the page: "a b c d sono li neruj che pigliano liodori" (*a b c d* are the nerves which take up [and so, record] odors). In the main drawing to the right these features are placed in relation to the base of the skull and some of the cranial nerves. Leonardo showed great interest in the physiology of sensation, particularly vision. The main point of these drawings was to demonstrate the path of vision from the back of the eyeball to the base of the brain. This he achieved with remarkable success. The olfactory bulbs and nerves are also well shown, lying above the optic nerves. He demonstrates with praiseworthy accuracy the delicate motor nerves to the muscles of the orbit, and the main (trigeminal) nerve to the face.

The main body of manuscript on this sheet recounts the method of dissection that enabled the artist to make these drawings:

> Ease away the brain substance from the borders of the dura mater [the hardest of the three membranes surrounding the brain].... Then note all the places where the dura mater penetrates the basilar bone with nerves ensheathed in it, together with the pia mater [the innermost of the three membranes surrounding the brain]. And you will acquire such knowledge with certainty when you diligently raise the pia mater, little by little, commencing from the edges and noting bit by bit, the situation of the aforesaid perforations, commencing first from the right or left side, and drawing this in its entirety; then you will follow the opposite side which will give you knowledge as to whether the previous one was correctly situated or not. Furthermore, you will get to understand whether the right side is the same as the left, and if you find differences, review the other anatomies to see whether such a variation is universal in all men and women.

Leonardo was probably the first to draw the optic chiasma, in another sheet at Windsor datable about 1500 (R.L. 12602R). The present sheet is datable about 1506–8.

In the lower drawing Leonardo is concerned with the blood supply of the uterus from the hypogastric artery, the remnant of which is shown curling upward toward the umbilicus.

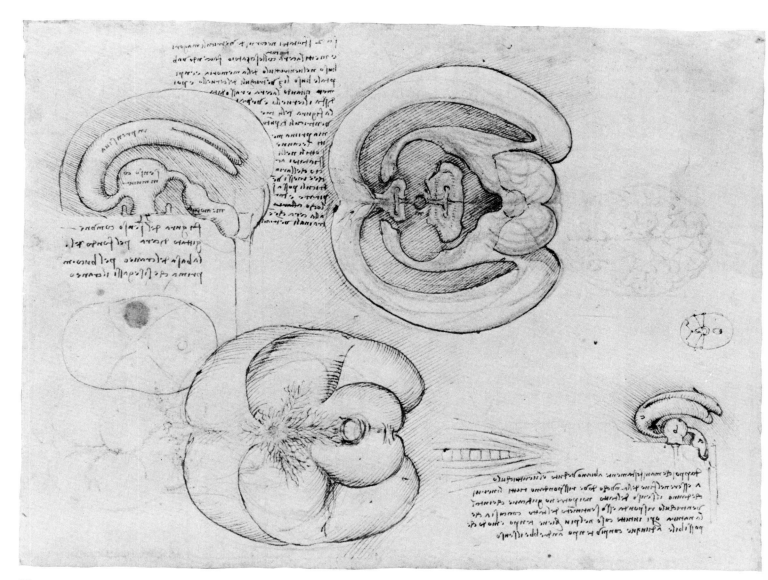

THE ALIMENTARY
AND REPRODUCTORY SYSTEMS

THERE IS only one sheet of drawings in this group that dates from before the turn of the century, and that is something of an exception (16A and B). Among the early metalpoint drawings of about 1487–89 are several early attempts at understanding the location and functioning of the internal organs of both man and animal, but the curiously naïve representation of the alimentary system in the subsidiary figure of 16A, dating from the 1490s, shows how far Leonardo still had to go to achieve the far more detailed and anatomically convincing views seen in 12A and B and 13A and B (of about 1506–8) and 14 (of about 1508–9).

The same advance can be traced from the traditional (and originally Hippocratic) view of the genito-urinary system seen in the main figures of 16A, to the magnificent series of studies of the babe in the womb (18A and B and 19A and B) dating from about 1510–12. In Leonardo's search for the key to human life he had concentrated first on the skull, and the location of the *senso commune,* and secondly on the human reproductive system. Already in 1489 he had noted, on the last page of Folio B (R.L. 19037R), regarding the contents of his proposed book on anatomy: "This book should begin with the conception of man and describe the form of the womb, and how the child lives in it, and to what stage it resides in it and in what way it is given life and food...." It was not until twenty years later that he was able to concentrate on embryology, doubtless because he came to discover that his anatomical knowledge was at the time of writing this note far from adequate for such a survey.

In his studies of the alimentary and reproductory systems, as in so many branches of his anatomical discussions, Leonardo makes frequent references to his work on animals and in many cases mistakenly applies his discoveries in animals to the human species. On 13A he draws the thoracic and abdominal organs of a pig, and on 13B he writes: "describe the differences of the intestines in the human species, monkeys, and the like. Then how they differ in the leonine species, then the bovine, and lastly birds." One of the most significant errors of the studies of the walls of the human uterus is Leonardo's inclusion there of cotyledons that are present in ungulates such as the cow (see 15A), but not in humans.

He evidently found it difficult to obtain suitable female bodies to dissect, and it is with some surprise that we encounter among the drawings of this section two sheets (17A and B and 18A and B) that contain drawings produced from a female model.

12A. The stomach and intestines

Pen and brown ink over traces of black chalk. 190 × 139 mm (R.L. 19031v)

The central drawing on this sheet represents the esophagus *(meri)* descending to the stomach with the intestines below. The different vertical stretches of the small intestine are labeled, from the stomach onward (in the key lower right): duodenum, jejeunum ("empty because it runs upward"), and ileum, passing through the monoculus or caecum (with appendix attached) to the final ascending, transverse, and descending colon (or large intestine), and thence to the rectum. The kidneys are shown lying just within the colon, to the left and right. This figure, and the enlarged one lower right, are the first known illustrations of the appendix. The accompanying notes concentrate on the "power" that moves the intestinal contents along. Leonardo performed very few investigations on live animals and so never observed peristalsis.

The figure bottom center shows the stomach with the rather tattered and shrunken liver and enlarged spleen found in the old man whose body provided the subject for a large number of the anatomical dissections of about 1506–8.

12B. The stomach and intestines and the physiology of the kidney and bladder

Pen and brown ink (two shades) over black chalk. (R.L. 19031r)

The central figure of the intestines on this sheet is far closer to the actual appearance of the alimentary tract than that on 12A. The duodenum is here correctly placed in between the jejeunum and ileum, rather than to their right. Leonardo measured both the small and the large intestine and found that the former was approximately twenty-six feet long, and the latter approximately six feet.

The lower part of the page is devoted to Leonardo's application of his work on the movement of water to the passage of urine from the kidney and ureter into the bladder, a discussion continued on 13B. In the fifteenth century Galen's idea that the ureters entered obliquely into the bladder wall and formed a valve mechanism preventing the reflux of urine was generally accepted. Leonardo could not agree with this and stated that as water never moves naturally except downward, the flow of urine into the bladder is governed by the position of the bladder in relation to the kidneys. That is, the flow of urine into the bladder is governed by hydrodynamic principles rather than the valvular action of channels in the bladder wall. This led the artist into the unexplored study of the effects of posture on urine flow into the bladder: the figures on the lower right-hand margin show, from top to bottom, the full bladder of an "upright" man, an "upside-down" man, a man lying on his side, and a man lying prone on his belly. Only in the last case can the bladder fill completely with urine, according to Leonardo's hydrodynamic ideas.

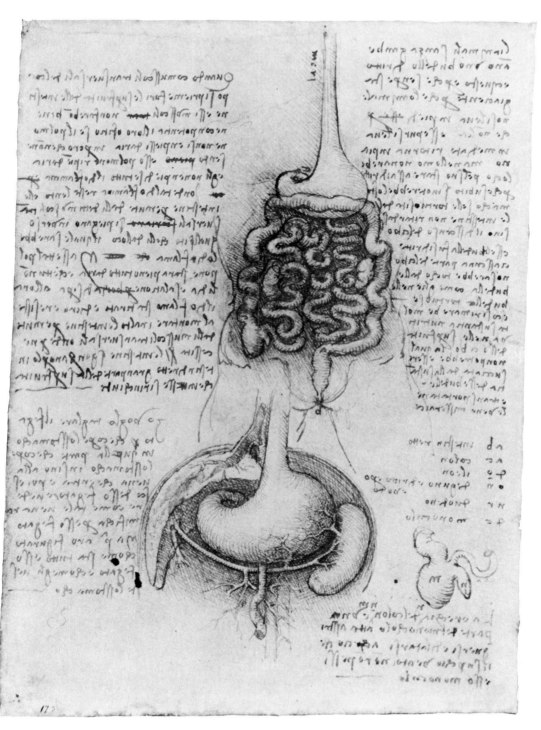

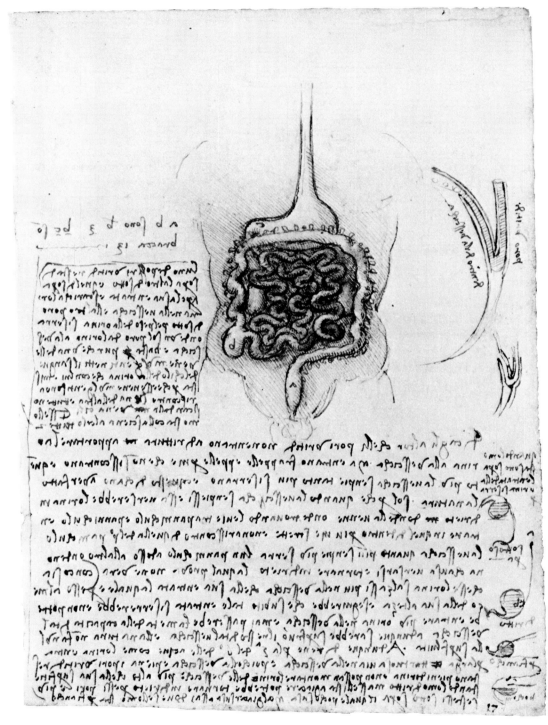

12B

13A. The thoracic and abdominal organs of a pig

Pen and brown ink (two shades) over traces of black chalk. 191 × 143 mm (R.L. 19054V)

In the right-hand drawing Leonardo has labeled the separate organs *polmone* (lung), *feghato* (liver), *milza* (spleen), *stommaco* (stomach), *djaflamma* (diaphragm), and *spina* (spine). At the top of this drawing the ends of the vessels are described as follows, from right to left: "a: trachea, whence the voice passes; b: esophagus, whence food passes; c: apoplectic [carotid vessels], whence passes the vital spirit; d: dorsal spine, where the ribs arise; and e: vertebrae, where the muscles arise which end in the neck and raise up the face toward the sky."

The same organs are seen, now from the front, in the figure to the left. Leonardo seems to have favored the pig for his investigations of the thoracic organs: he inflated a pig's lungs to make another demonstration in one other drawing at Windsor (R.L. 12593V). The notes surrounding this figure are concerned with the problem of visual representation of the lungs, heart, and pulmonary vessels. Leonardo sets himself the task of making eighteen views of the thoracic contents alone, and numerous others of the other organs. He discusses the technique of representing organs in depth by penetrating (or "fenestrated") views. "You will first make this lung complete, seen from four aspects in its complete perfection; then you will make it in a fenestrated view solely with the ramification of its trachea, from four other aspects."

Like the drawings on the previous sheet, these studies should be dated about 1508–9.

13B. Three views of the bladder, with kidneys, ureters, and urethra, and detail of entry of ureter into the bladder

Pen and brown ink (two shades) over black chalk. (R.L. 19054R)

The three main diagrams show both the method of entry of urine into the bladder and the veins and arteries of the bladder wall, which Leonardo believed ascended from below. The smaller figure top left shows a detail of the bladder wall and the "crosswise channels" by which the ureters penetrate this wall.

The text surrounding these diagrams continues that on 12B regarding the flow of urine from the kidney down the ureters (marked *L* and *h* in the left-hand illustration) into the bladder. Leonardo refers to his "Book on Conduits" for an explanation of the hydrodynamic principles involved.

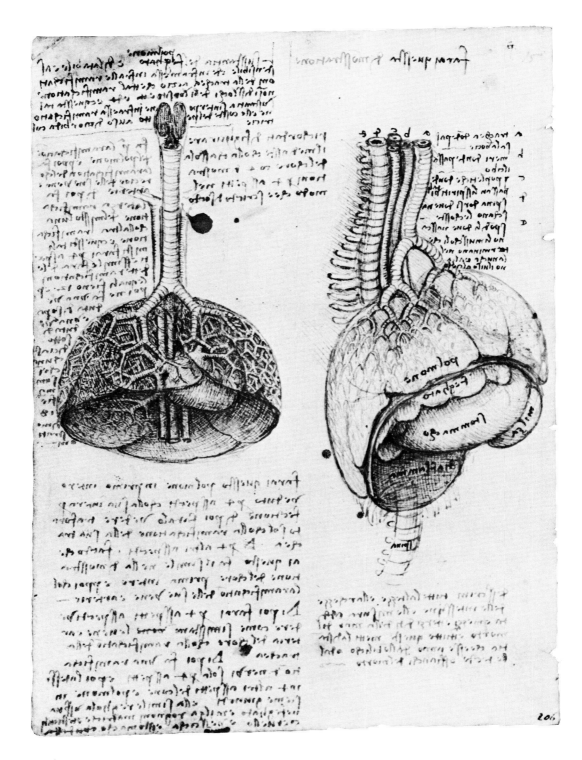

13A

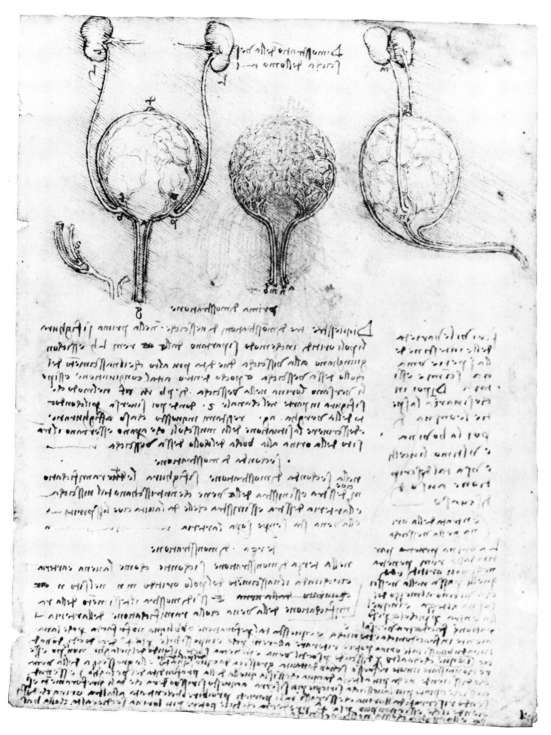

[The text on this page is written in Leonardo da Vinci's mirror-writing and is not legibly transcribable in standard orientation.]

14. *Lungs, bladder, and male genitalia*

Pen and brown ink (two shades) over
black chalk. 279 × 191 mm
(R.L. 19098v)

Apart from the drawing of a pig's lung with its lobe lying over the heart (top left; compare 13A), this page is devoted to studies of the male genitalia and of the blood supply to the pelvic organs, shown in the central figure. The two masterly drawings of the bladder and male genitalia are remarkable for their representation of the course of the vas deferens arising from the testicles and passing to the seminal vesicles on the lower side of the bladder. The accuracy with which the ejaculatory duct is shown entering the urethra just beyond the internal sphincter of the bladder shows Leonardo's mastery of the anatomy of this region. He even understood the mechanism of hernia formation, demonstrating here "the way the intestines descend into the sac of the testicles."

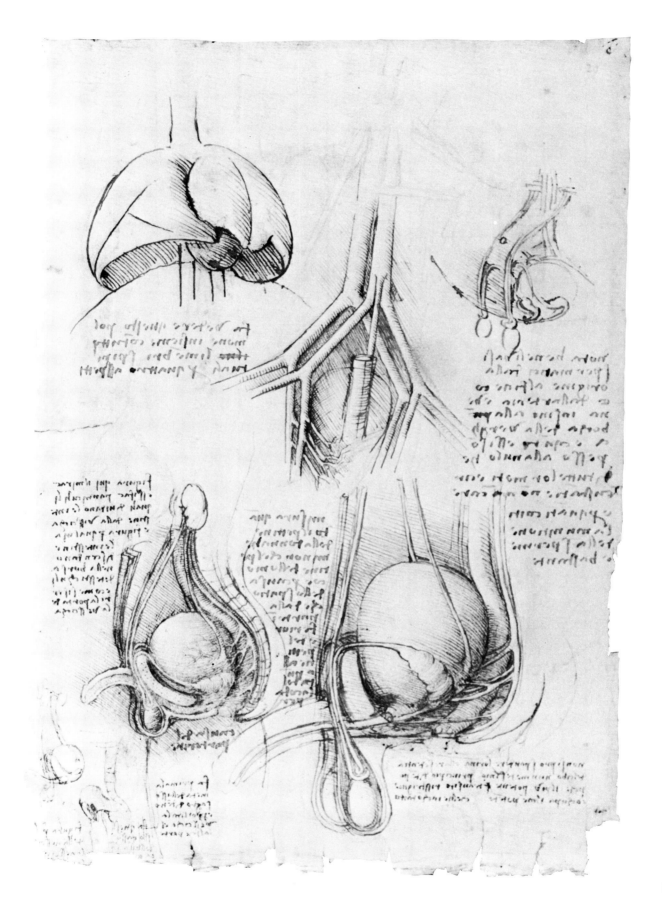

15A. *The fetal calf in utero*

Pen and brown ink over traces
of black chalk. 192 × 142 mm
(R.L. 19055R)

The upper drawing illustrates the bicornuate (double-horned) uterus of the cow from the outside, with its blood supply from the vessels marked *a b c d*. Below, Leonardo puts into dramatic effect his transparency technique of demonstration, producing an incomparable picture of the patchy placental cotyledons (*rosette chanose,* or fleshy rosettes) through which the mother's blood reaches the fetus, with the fetal calf within. This can be seen lying upside down, its head to the left, its forelimbs bent, with visible cloven hoofs above, and its hind limbs clearly visible to the right. Into its umbilicus in the middle of the body run the umbilical vessels. Below this he draws the maternal and fetal cotyledons half separated to show how they interdigitate "just as the fingers of the hands are interwoven, one in the space between the others...." Elsewhere in the text Leonardo discusses how the fetal and maternal layers of the chorion (containing the cotyledons) separate at birth. He believes that after birth the uterus contracts so that the cotyledons are brought close together, like the cells of a beehive (see diagram top left). So united, they are expelled as the afterbirth in "one piece of flesh" (as does indeed happen in the cow).

15B. *Movements of the mouth and lips*

Pen and brown ink (two shades) and
black chalk. (R.L. 19055V)

It is a far cry from these studies of the lips to the smile of the Mona Lisa, yet Leonardo was probably engaged on both at the same time, about 1506–8. Top left is a study of tightly pursed lips, and next to it a slightly smiling mouth. Below the study of pursed lips Leonardo writes: "The ultimate shortening of the mouth is made equal to half its greatest extension and it is equal to the greatest width of the nostrils of the nose and to the interval interposed between the lachrymal ducts of the eye." He continues: "the muscles called lips of the mouth in narrowing themselves toward their center pull behind them the lateral muscles; and when the lateral muscles pull so shortening themselves, then they pull behind them the lips of the mouth and so the mouth is extended, etc."—first steps toward the anatomy of a smile. The sketches down the right margin show: above, retracted lips through the intact skin; below, the skin has been removed to show how the buccinator and muscles of the lips perform these movements.

The little drawing between the studies is labeled "womb of a cow." Inside the uterus can be seen the form of a little fetal calf. This is a typical example of Leonardo's small preparatory sketches, to be developed in detail on the other side of the sheet.

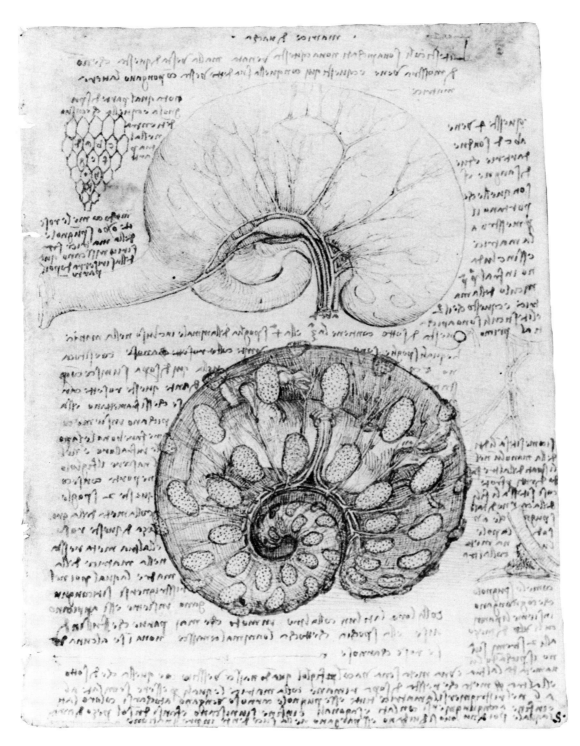

15A

67

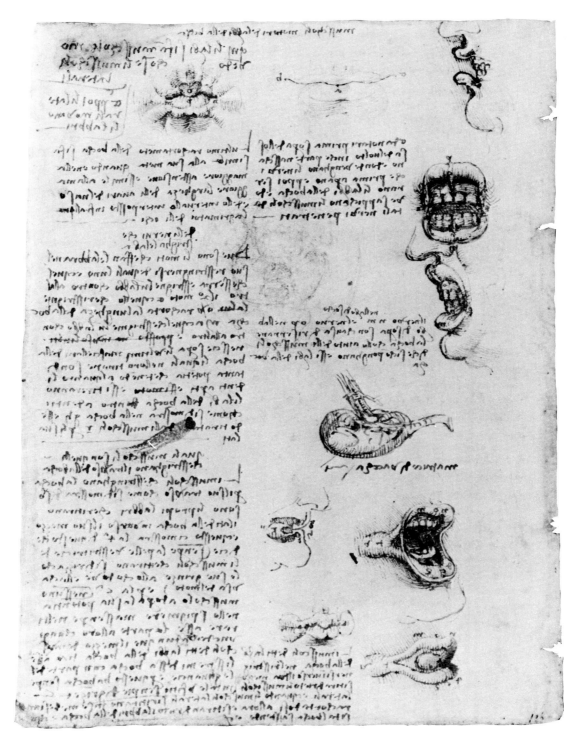

16A. *Coition of hemisected man and woman*

Pen and dark brown ink, with black lead numbering of manuscript passages added in a nineteenth-century hand.
276 × 204 mm (R.L. 19097v)

This page is headed: "I display to men the origin of the second—first or perhaps second—cause of their existence," and at the bottom of the sheet: "Here two creatures are divided through the middle, and the remains are described." The main drawing illustrates almost entirely traditional notions on the generative act; notions drawn chiefly from Avicenna and Galen. Avicenna stood fast in the Hippocratic belief that "the most active and thickest part" of the semen, carrying the animal spirit or soul to the future embryo, comes from the spinal cord. Leonardo's drawing shows a tube carrying the semen from the lumbar regions of the cord into the penis, where it occupies the upper of two passages. The lower of these carries semen from the testes, as well as urine from the bladder. The corrugated appearance of the uterus derives from the medieval idea that its cavity was divided into seven cells. The epigastric veins are shown leaving the upper side of the uterus with the blood of the retained menses, and carrying this to the breasts for the formation of milk.

The drawings on this sheet date from about 1492–94, at a time when Leonardo made few other anatomical studies. During his next great spate of anatomical activity, in the first decades of the sixteenth century, he abandoned many of the old ideas incorporated in this figure, on the basis of his findings in dissection and experiment. His later discoveries are foreshadowed to a certain extent in the memorandum at the center of the present sheet. "Note what the testicles have to do with the coition and the sperm. And how the fetus breathes and how it is nourished through the umbilical cord, and why one soul governs two bodies, as you see the mother desiring a food, and the child remaining marked by it. And why a child of eight months does not live." He goes on to criticize at least one of his sources, Avicenna: "Here Avicenna pretends that the soul generates the soul and the body the body and every member—*per errata.*" About fifteen years later than the drawings on this sheet Leonardo made the following note, on 32B: "The act of coitus and the parts employed therein are so repulsive that if it were not for the beauty of the faces and the adornments of the actors and frenetic state of mind nature would lose the human species."

The figure bottom left shows a highly misleading view of the alimentary tract, in which Leonardo has applied his knowledge of animal anatomy to humans.

16B. *Arteries, veins, and genito-urinary system of an animal, probably a horse*

Pen and brown ink (two shades).
(R.L. 19097R)

This sheet represents one of Leonardo's few dissections of a horse. Perhaps more important than the drawings, however, is Leonardo's note, lower left: *quãdo tu · aj finjto dj cressciere lomo · ettu faraj · lasstatua · chõ tutte · sue · mjsure—superfitialj.* (When you have finished making the man, you will make the statue with all his superficial measurements.) This was formerly thought to relate to the Sforza monument, but it is now generally accepted that it concerns the making of an anatomical model, to which Leonardo alludes frequently in notes.

Another reference to Leonardo's anatomical method is found in the passage to the left of the left-hand kidney: "dissect a kidney and leave only the vessels, and this you will do if you boil it."

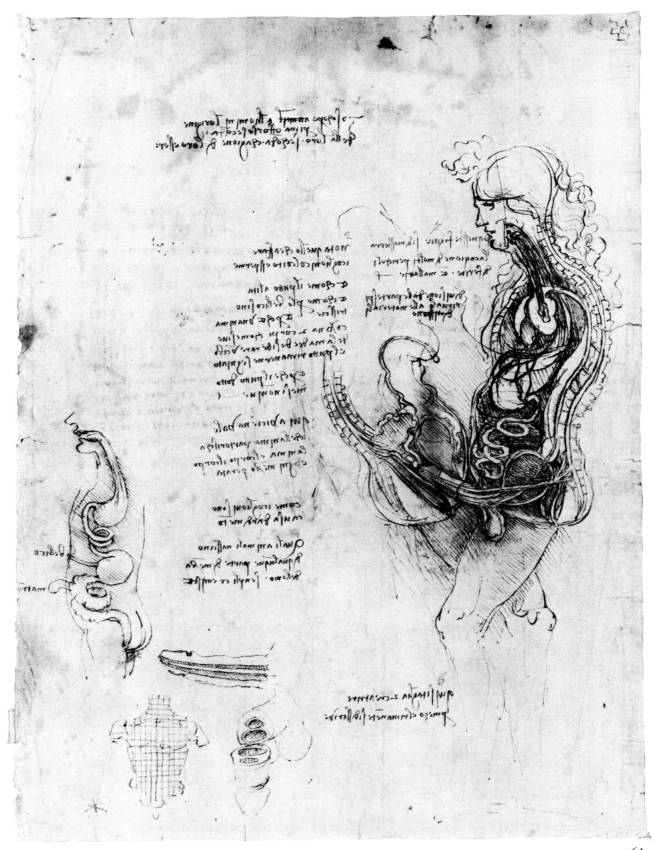

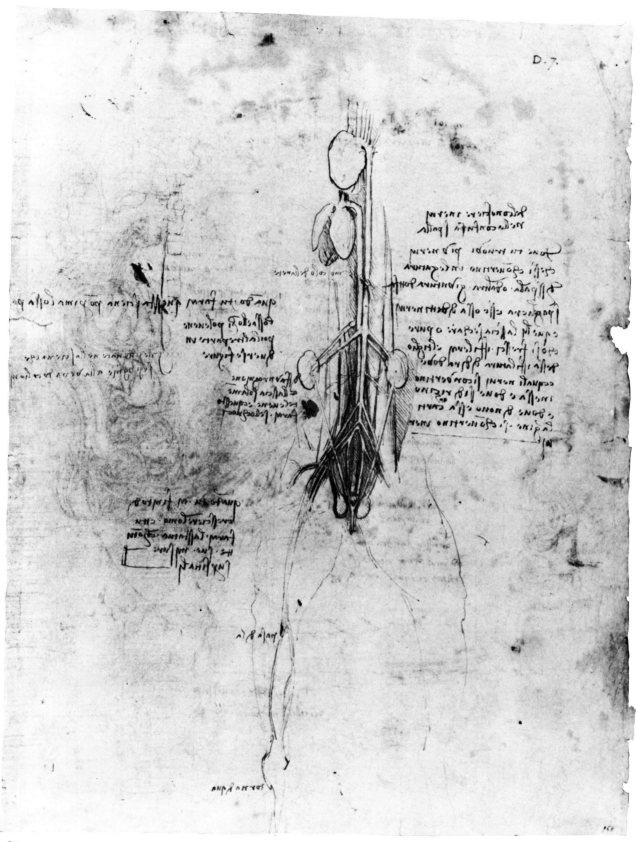

17A. *The external genitalia and vagina, with diagrams of the anal sphincter*

Pen and brown ink (two shades) over black chalk. 191 × 138 mm
(R.L. 19095R)

Leonardo regarded all the main "gaps" in the skin of the body as orifices with mechanisms for opening and shutting—in short, as sphincters. The sphincter mechanism is explained elsewhere as one that "receives necessary things and drives out superfluities."

The main drawing occupying the upper part of this sheet depicts the vulva in what would appear to be a multiparous woman, after childbirth. The labia, spread widely apart, show no evidence of a hymen, labia minora, or clitoris. The urethral orifice anteriorly appears unduly prominent and the corrugated transverse rugae of the widely opened vagina are clearly shown.

The smaller drawings constitute Leonardo's main attempt to solve the complex problem of the anal sphincter. He has marked the largest, central, figure *falso* (false) and concludes that there are five, not three or seven, muscles in the sphincter. The sheet is datable about 1508–9.

17B. *Male and female genitalia and side view of a woman in early pregnancy*

Pen and brown ink (two shades) over traces of black chalk. (R.L. 19095V)

The drawings and notes on this sheet show Leonardo attempting to establish analogies between the two sexes. The pairs of diagrams top right and bottom left show male and female generative organs. The upper, female, organ is shown with ovaries at either side, with a hypothetical duct leading from its lower end to the uterus as a supposed analogy to the male ductus deferens.

The larger figure just above the center of the sheet shows a schematized view of the uterus, with three paired structures entering it at either side. The lowest of these is the vas seminarium carrying sperm from the ovary. Above this is a hypothetical vessel extending to the front wall of the abdomen, carrying blood of the retained menses during conception to be converted by the breasts into milk. The third (and uppermost) pair of vessels are the uterine tubes giving the human womb the same bicornuate appearance as that of animals.

In the side view of the female figure bottom right, showing the uterus in early pregnancy behind an enlarged bladder, each of the tubes entering both the bladder and the uterus, so carefully drawn in 13B and 15B, can be made out. Female figures occur so rarely in Leonardo's drawings that it is worth noticing the type used in this purely scientific drawing. The carriage of the torso and the high, full breasts recall the proportions of the Leda, painted by Leonardo at around the same time as the drawings on this sheet were made, about 1504–9.

The note in the center of the sheet reads as follows: "The child lies in the uterus surrounded with water, because the heavy things weigh less in water than in the air, and the less so the more viscous and greasy the water is. And then such water comparts its own weight with the weight of the creature over the whole bottom and the sides of the uterus."

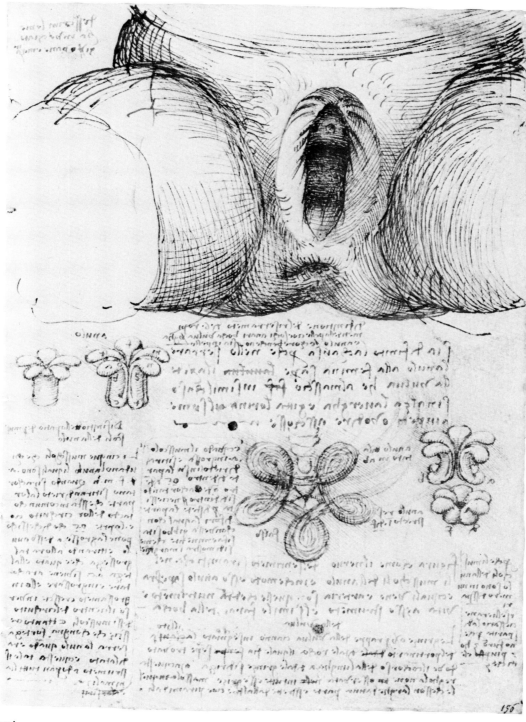

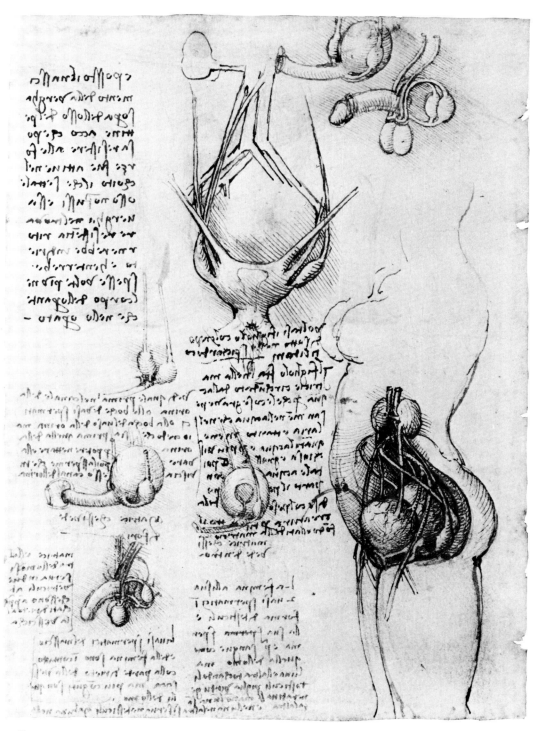

17B

18A. The female external genitalia and five views of the fetus in the womb

Pen and brown ink (three shades) with red and black chalk.
303 × 220 mm (R.L. 19101R)

The two drawings at the top of the sheet show the female external genitalia with far greater accuracy than 17B and were probably executed a few years later than the drawings on that sheet. The drawing at the right depicts (inaccurately) the supposed arrangement of the abdominal muscles. A large part of the manuscript down the left-hand side of the page relates to the relative lengths of the female organ in humans and in other animals and the "length" of the human at birth and in maturity.

The main drawings on this page are studies of the fetus in the uterus seen from different aspects. Leonardo is also concerned with the length and position of the umbilical cord and states that "the length of the umbilical cord is equal to the length of the child in every stage of its growth." In the notes Leonardo considers whether the fetus breathes, cries, or passes urine while in the uterus. He concludes: "The child does not respire in the body of its mother because it lies in water, and he who breathes in water is immediately drowned...and where there is no respiration there is no voice." Leonardo believed that the tucked-in left heel of the fetus, pressing on the perineum (as drawn) prevented the passage of urine into the uterus; the infant's urine instead passes down its umbilical cord.

The inscribed "tablet" at the upper edge of the sheet contains the following words: *Dimanda la moglie di biagin Crivelli come il cappone alleva le oua della ghallina essendo lui imbricato.* (Ask Biagino Crivelli's wife how the capon rears and hatches the eggs of hens when he is unplucked.) Biagino Crivelli, the favorite and head of Duke Lodovico Sforza's crossbowmen, was well known to Leonardo during his time in Milan. It is possible that he hoped to discover clues to the development of the human fetus by studying the incubation of the chicken egg.

18B. Miscellaneous anatomical studies

Pen and brown ink (three shades).
(R.L. 19101V)

The main drawings on this sheet are those covering the lower half, representing the viscera, blood vessels, and umbilical cord of the fetus shown top right. Leonardo states that this was four months old, but it appears to be a month or so older. In these studies the flow of blood can be traced from the placenta up the long sweep of the umbilical vein, through the fetal umbilicus upward toward the liver. The fetal umbilical arteries, converging on the umbilicus, are also clearly shown, with the bladder below. In the small drawing on the right margin the cotyledons found in the ox's womb (15A) are added at the end of the human umbilical cord. On the upper edge of the sheet are three drawings showing the umbilical cord in section: Leonardo states that "the umbilical vein is always as long as the length of the child." The text surrounding these drawings is concerned chiefly with the nourishment of the fetus, which was achieved, according to Leonardo, by the flow of maternal fluids from the mother to the fetal liver via the umbilical vein.

The drawings just above the middle of the page represent the bones and tendons of the right elbow and forearm, concentrating on the brachialis muscle (marked *a*), producing flexion alone, and the biceps (marked *b*), enabling supination, a subject that was of perennial interest to Leonardo.

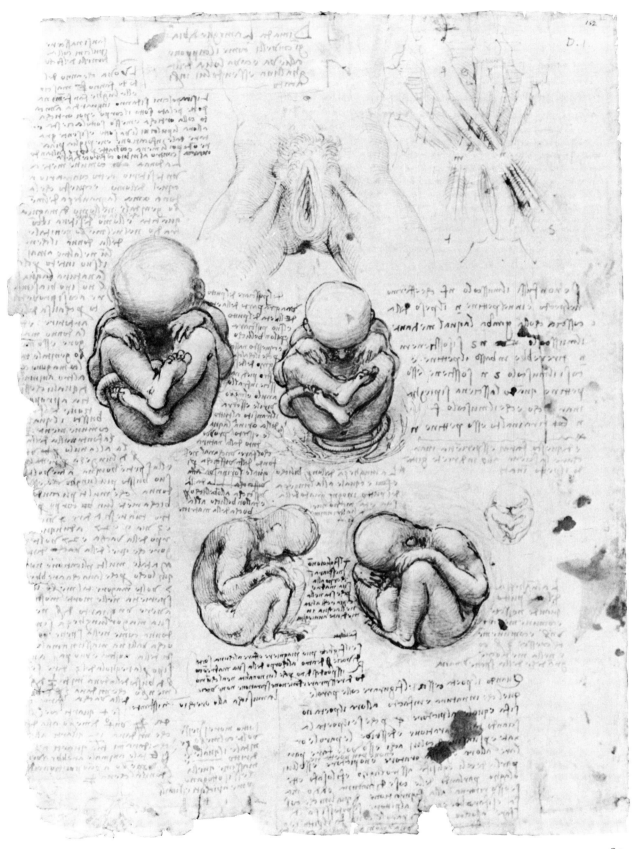

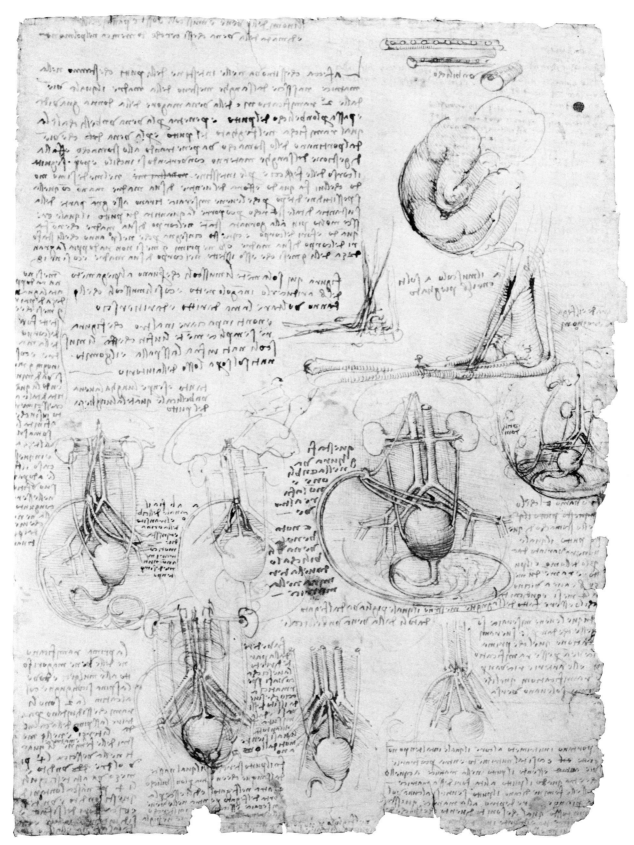

19A. *The infant in the womb*

Pen and brown ink (three shades)
with wash modeling over traces of
black chalk, and red chalk. 305 ×
220 mm (R.L. 19102R)

Here Leonardo displays "the great mystery" of the womb: how it encloses the growing fetus within. He has apparently sliced open a uterus containing the same fetus as that shown in 18A and B, in the breech position. The fetus displays the same features as are seen in the drawings on 18A and B, such as the tucked-in heel and the winding umbilicus. Leonardo mistakenly included in the vascular walls of the human uterus the cotyledons (inter-digitating processes) that he had found in the uterus of the cow (15A) some five years before.

The remaining drawings show the interdigitations by which the fetus is physically joined to, yet with a separate vascular system from, the mother's placental blood supply. To the right of the main drawing the infant is seen through the transparent amniotic membrane, floating and growing in its waters just as, in Leonardo's view, the earth grows out of its surrounding seas. Bottom right is a small diagram concerning binocular vision.

19B. *Dissection of the human fetus*

Pen and brown ink (two shades).
(R.L. 19102V)

This "working" page of notes, though unattractive, is typical of those in which Leonardo developed his ideas at different times through small sketches and jottings. There are notes on subjects such as blood vessels, membranes, and the intestines of infants. At the center is a drawing of the heart, liver, stomach, and intestines of the fetus, continuing those of other fetal organs drawn on 18B. Leonardo is struck by the way "the liver withdraws to the right side" in the adult, as compared with the fetus, where it is central, and explains this by the "loss of function" of the umbilical vein and the development of the spleen after birth.

In the sectional drawing center right Leonardo draws an early embryo and its coverings in section and labels the layers (from the outside inward): *secondina* (chorion), *alanchoidea* (allantois), *animo* (amnion), and *matrice* (uterus). This diagram is further discussed in the six lines of writing in an unknown sixteenth-century hand. Apart from the evidence of this note, there is nothing else to suggest that any of Leonardo's pupils made a deep study of anatomy. The four lines of writing at the top of the page and two diagrams concerned with the formation of shadows below and to the right are in the hand of Francesco Melzi, Leonardo's favorite pupil, who inherited all his notebooks and papers.

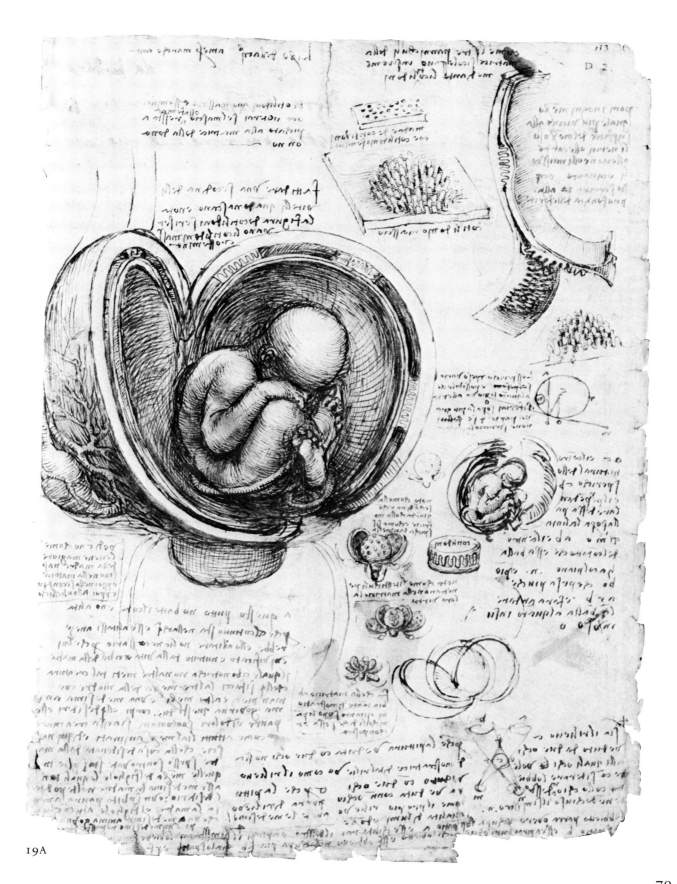

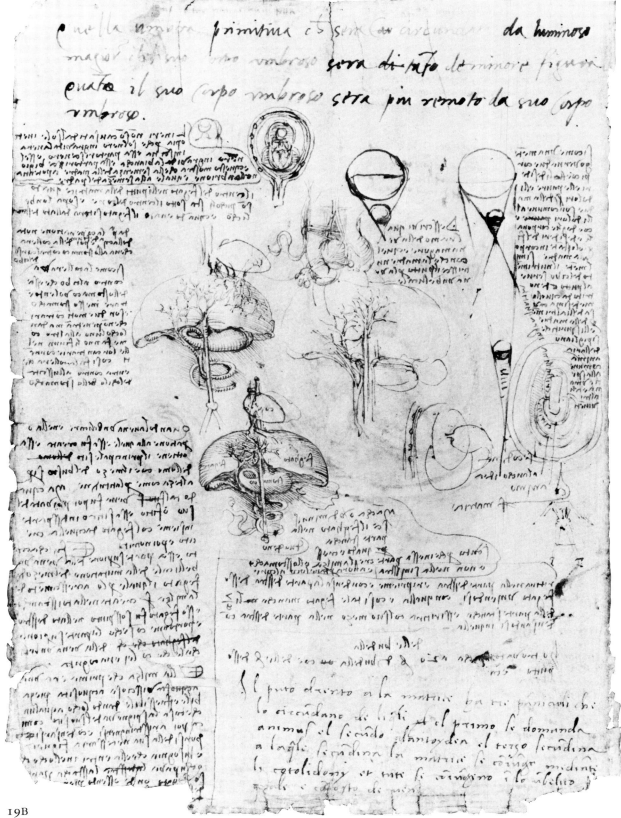

MUSCLES AND SKELETON

THE GREATER PART of Leonardo's fully worked drawings on the osteological and myological systems date from after those of the abdominal organs. He concentrated on the human musculature and skeleton particularly during the period 1508–10 in the pages of Folio A, to which drawings 20 and 25–33 belong. On the other hand, the earliest of Leonardo's anatomical drawings are of the skull (e.g., 8A and B), dating from 1489, while 24 is among the latest, dating from about 1513. The deterioration in both illustrative clarity and anatomical accuracy is self-evident in the latter drawing.

Leonardo's drawings of the human skeleton are among his most impressive and beautiful studies. In them we can see put into practice his stated principle that good draftsmanship will tell more than a thousand words (see 20A). The drawings of muscles are understandably less accurate than those of bones, and myology was purely anatomical exploration. In Leonardo's time it was neglected. In his detailed studies of the muscles of the hand and face (32A and B, and 30B), for instance, he achieved a remarkable degree of accuracy.

The pages of Folio A are dotted with Leonardo's notes concerning his illustrative techniques. He believed that each limb, part, and even bone should be shown from at least five viewpoints, and at various depths. In the case of the hand (and elsewhere) he included the time dimension and suggested that these "demonstrations" should be made on an old man, a young man, and a child, to achieve yet greater clarity and understanding. On 25A and 26A Leonardo depicts a series of eight views of the muscles of the shoulder and arm by rotating the same figure 180 degrees. He devised an ingenious method of illustrating the location and power of muscles by means of "cord diagrams": on 28B he drew such a diagram of the shoulder and on 32B laid down the principles for another of the hand. "When you have drawn the bones of the hand...make threads instead of muscles...in order that one should know what muscles go below or above another muscle."

Reminders that these demonstrations and dissections had a practical as well as a theoretical use are contained on 22A and 27A, in which Leonardo refers to the examination and treatment of wounds and the necessity for a thorough anatomical knowledge of the body.

20A. *The spine*

Pen and brown ink (two shades) with wash modeling over traces of black chalk. 286 × 200 mm (R.L. 19007v)

On the upper half of the page the articulated human vertebral column is shown in all the beauty of its natural curvatures and with correctly numbered vertebrae in each part. Never had this been achieved before. To the right the vertebral column seen from the front is so skillfully drawn and shaded that one can see the curvatures in its perspective. Below, Leonardo lays it on its side to draw it from the back. In the notes he suggests that each part of the spine should be drawn "separate and then joined together," not only from the "three aspects" (front, side, and back), but from below and above as well. This examination should be applied particularly to the seven vertebrae of the neck, seen bottom left. By the side of the sheet Leonardo's fascination with the unusual conformation of the first three cervical vertebrae led him to give a separate "exploded" posterior view of their articulations. "You will draw the bones of the neck from three aspects joined together, and from three aspects separated," Leonardo writes, and

thus you will give true knowledge of their shapes, knowledge that is impossible for either ancient or modern writers. Nor would they ever have been able to give true knowledge without an immense, tedious, and confused length of writing and time. But through this very short way of drawing them from different aspects one gives a full and true knowledge of them. And in order to give this benefit to men I teach ways of reproducing and arranging it, and I pray you, O successors, not to be constrained and get them printed in....

Here the text becomes illegible and breaks off, but it is clear from this passage that Leonardo hoped that his anatomical studies would be published.

20B. *Surface anatomy of the neck and shoulder*

Pen and brown ink and black chalk. (R.L. 19007R)

In the bottom left-hand corner of the sheet is the name "Leoni," which is perhaps the signature of the sculptor Pompeo Leoni, who once owned the collection of drawings by Leonardo now at Windsor.

The drawing shows the surface anatomy of the neck and shoulder in a thin old man, possibly the same subject portrayed in 31B and 33B. The raised arm, flexed at the shoulder, brings the triceps muscle of the upper arm into marked relief. Running along the right of the sheet is a faint black chalk drawing of the right shoulder and arm seen from above.

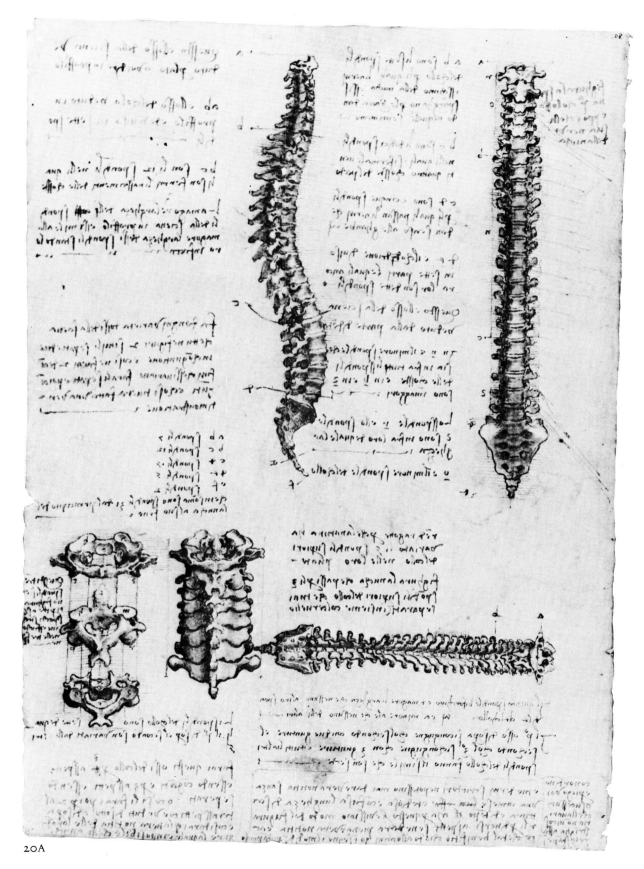

20B

21A. *The upper spinal cord with dependent bones and nerves*

Pen and brown ink (two shades).
191 × 137 mm (R.L. 19040R)

The key to this page is given in the three lines of writing just below the center at the left edge of the sheet: *La nucha effonte de nervi che dā moto volontario alle mēbra.* (The spinal cord is the source of the nerves that give voluntary movement to the limbs.) By sawing the spinal cord in half (upper drawing), Leonardo has revealed the nerves running from the brain above down the spinal cord and then breaking out to either side to form the brachial plexus. In the lower drawing the base of the brain, the spinal cord, and the brachial plexus have been removed from their encircling bones and membranes to be shown on their own. These drawings, and two others on a sheet that was formerly next to it (R.L. 19021), reflect an error in the anatomy of the central nervous system that Leonardo never corrected. His belief that the spinal cord consisted of one central and two lateral channels probably dates back to his dissections of a frog and a monkey in 1487 (see 5B).

21B. *The formation of the brachial plexus of the arm*

Pen and brown ink (two shades) over black chalk. (R.L. 19040V)

In the drawings on the other side of this sheet (21A) the brachial plexus was shown greatly oversimplified. The present page is headed: "Here each nerve of the arm is joined to all; and four nerves that issue from the spinal cord," and the three drawings on 21B show that Leonardo here achieved a much clearer idea of the actual layout of the plexus, although he overlooked the fifth root attaching the plexus to the spinal cord (seen top left). His advance in this area of human anatomy over some seventeen years can be appreciated by comparing the brachial plexus in this drawing to the depiction of the shoulder in 4, in which the roots are seen emerging from the spine and passing below the clavicle in simple formation, without any plexus at all.

The muscles of the right-hand drawing are labeled as follows (top to bottom): *spalla* (shoulder), *omero* (humerus), *pesse del braccio* (fish of the arm; i.e., biceps), *muscolo del gomjto* (muscle of the elbow; i.e., triceps). Bottom left Leonardo lists the *dimosstrationi* he intends to make on bones, tendons, vessels, intestines, and other branches of anatomy.

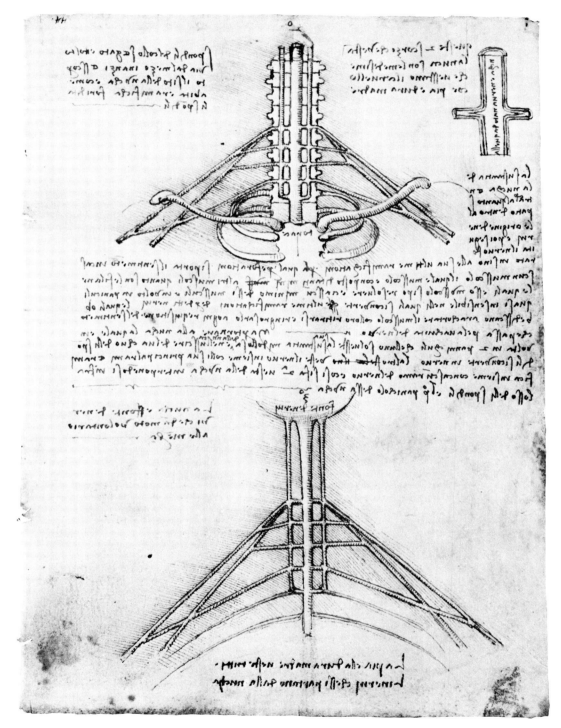

21A

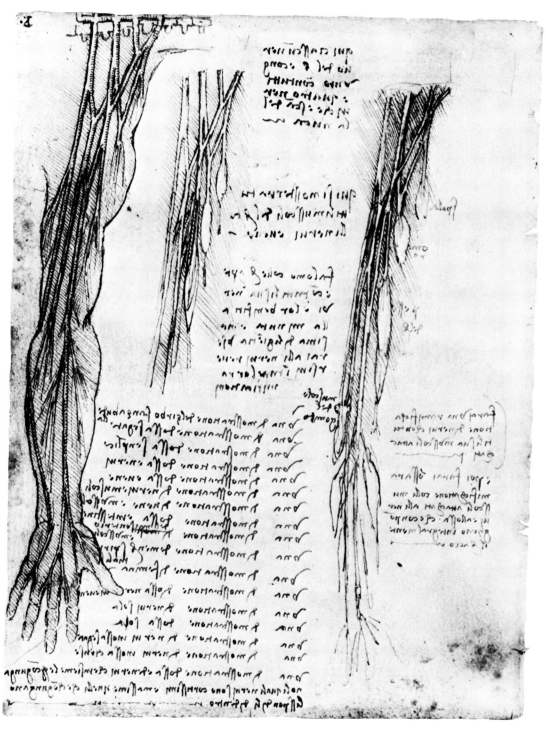

21B

22A. *The brachial plexus and discussion concerning muscles*

Pen and brown ink (two shades) over traces of black chalk. 192 × 143 mm (R.L. 19020v)

Two themes are considered on this sheet by Leonardo: the brachial plexus, described in the visual language of the drawing across the center of the sheet and the force of muscles, discussed in the notes.

Since the study of the plexus on 21A and B a little time before, Leonardo has evidently carried out further dissections, for the plexus is now correctly endowed with five (not four) roots, uniting to form upper, middle, and lower trunks. The main figure on this sheet is labeled *del vechio* (of the old man). On another sheet Leonardo gives details of how the old man died in the Hospital of S. Maria Nuova in Florence, and how he "made an anatomy" of his body (see page 12). There is good reason to date this event and the drawings of his dissected body (e.g., 22A) to 1508. The smaller drawings bottom right relate to the anterior vertebral muscles, labeled *a b c d e* in the main diagram and seen in cross section in the bottom right-hand corner. Just above the main drawing of the plexus Leonardo writes: "Any one of the five branches saved from a sword-cut is enough for sensation of the arm," suggesting that the artist had clinical experience of such an event, perhaps gained during Cesare Borgia's campaigns of 1502–3, in which Leonardo saw active service.

The manuscript notes hardly concern the drawings at all and are instead devoted to a discussion *della forza de mvsscholj* (on the force of muscles), according to the heading. In his notes Leonardo foreshadows the more advanced study of musculature carried out by him a few years later in the pages of Manuscript A. At this stage he is intrigued by the fact that nerves, muscles, and arteries are easily broken, but at the same time capable of exerting considerable force. He explains this phenomenon by the presence of membranes surrounding the muscle fiber.

22B. *The mesentery of the bowel and its blood supply*

Pen and brown ink (two shades) over traces of black chalk. (R.L. 19020r)

The notes and drawings on this sheet refer to the Galenical system (adhered to also by Mondino and Leonardo) whereby chyle absorbed from food in the intestine is carried by the superior mesenteric and portal vein (seen in all but one of the diagrams) to the liver, where it is turned into blood; at the same time this vein "nourishes" the mesentery, beautifully drawn by Leonardo in the two central diagrams.

The passage at the top of the page is one of several on miscellaneous pages of notes by Leonardo referring to his interest in fashion: "Long nails among Europeans are deemed shameful. Among Indians they are held in great veneration; and they have them painted with penetrating fluids and adorn them with various patterns; and they say that such practices are for gentlefolk and that short nails are for laborers and mechanics in different trades."

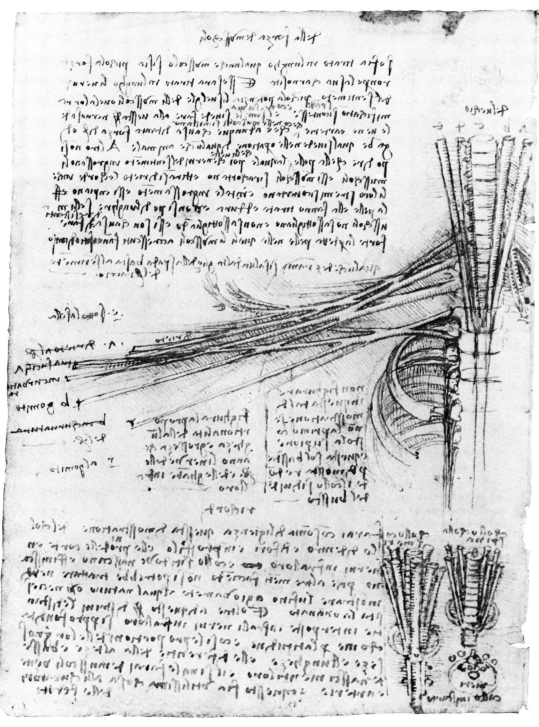

22A

23A. *The tree of the nerves*

Pen and brown ink. 190 × 134 mm
(R.L. 19034v)

Just as in the first drawing of this exhibition Leonardo demonstrated the "tree of the veins," so in the two main drawings on this sheet he depicts the "tree of the nerves, and it is shown how they all have their origin from the spinal cord and the spinal cord from the brain." Along the top of the sheet Leonardo makes the following observation: "The whole body takes origin from the heart inasmuch as its primary creation is concerned, therefore the blood, vessels, and nerves do the same; however, all the nerves manifestly arise from the spinal cord remote from the heart, and the spinal cord consists of the same substance as the brain from which it is derived." The drawings on this sheet, which is from Folio B, should be dated about 1506–8.

23B. *The lungs and respiratory system*

Pen and brown ink (two shades).
(R.L. 19034R)

The figure top right illustrates the lungs in the thorax. Leonardo's mention of the dissection of a pig's lung in his notes suggests that the diagram may represent the lung of a pig.

In the notes Leonardo poses himself several questions, such as: "If the lung contracts on expiration, what fills the pleural cavity? If the lung expands on inspiration, where do the contents of the pleural cavity go?" He evidentally at this time followed Platonists in thinking that the lung was inflated like a balloon from within.

24. *The muscles of the neck*

Pen and brown ink (two shades) on blue paper. 277 × 205 mm
(R.L. 19075v)

This is one of Leonardo's last anatomical drawings and dates from after 1513. It is designed to show how the neck is stabilized by muscles arising from the shoulder girdle so that the head can move freely on this firm axis. "You will first make the cervical spine without the skull with its cords, like the mast of a ship with its stays. Then make the skull with its cords, which give it movement on its fulcrum."

The drawings illustrate how much of his detailed anatomy Leonardo had forgotten since making the drawings on 27B, for instance, though retaining their central theme. This sheet expresses in anatomical language the pathos of his age and probable illness. In the passage bottom left he exclaims: "Oh Speculator of this machine of ours [i.e., the human form], you shall not be distressed that you give knowledge of it through another's death; but rejoice that our Creator has his intellect fixed on such excellence of instrument."

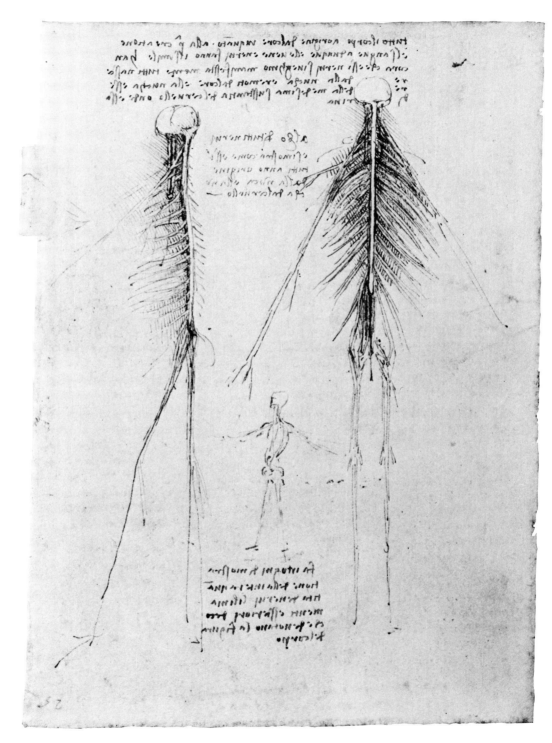

B.17

85

23B

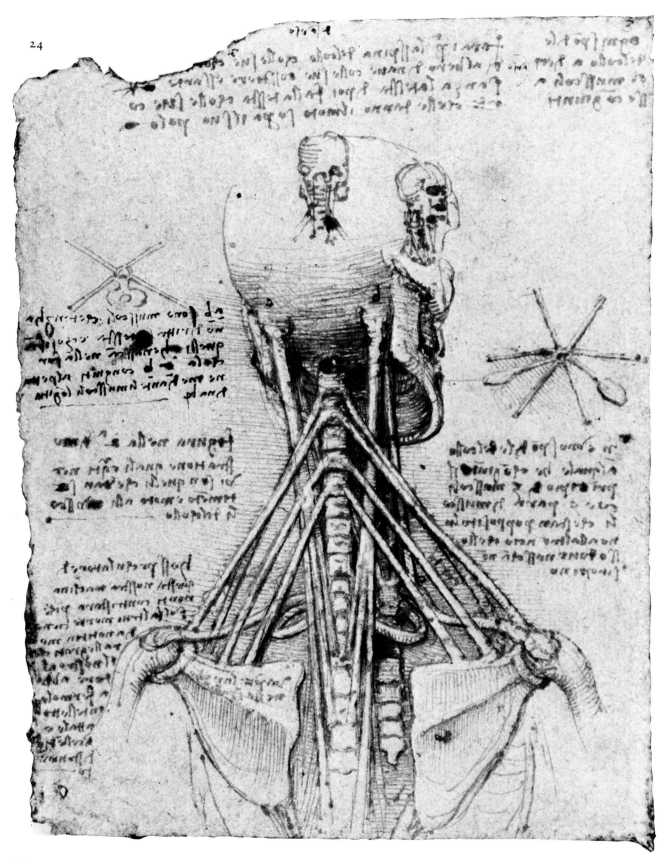

25A. Muscles of the arm in rotated views

Pen and brown ink (two shades) with wash modeling over black chalk. 289 × 199 mm (R.L. 19005v)

This series of drawings of the superficial muscles of the arm presents (from left to right) four views, commencing with that from the back and turning the body 90 degrees to show the right-hand side. The series is completed on 26A. Particular attention is given to the deltoid muscle, which is divided into four separate slips, marked *a–d* in the right-hand drawing, because each of these, in Leonardo's view, exerts a different action and therefore is a different muscle. The notes concern both the action of the deltoid muscle and procedures to be observed in order to make drawings of muscles "more intelligible" in terms of their mechanical actions. "And this will be an advantage for sculptors who have to exaggerate the muscles that cause the movements of limbs more than those [muscles] that are not employed in such movement."

The two lines of writing at the top of the page and the drawing top right are unrelated to the main theme. The note reads as follows: "The principal and most powerful muscles that are in man are the buttocks. These are of marvelous power as is demonstrated on the occasion of the force exerted by a man in lifting weights." The diagram represents the tongue, throat and uvula, and is related to other drawings of the throat on 29A.

25B. Superficial muscles and veins of the arm

Pen and brown ink with wash modeling over traces of black chalk. (R.L. 19005R)

The right side of the page is devoted to a study of the superficial veins of the arm, chest, and abdomen, carrying to a further stage the examination of the surface anatomy of the old man seen in 27A. The patterns of drainage of the cephalic and basilic veins of the arm, the mammary veins of the chest, and the superficial epigastric veins of the abdomen are beautifully shown. Below on the right Leonardo analyzes the deeper reaches of the basilic vein, following it with its branches through the axillary vein up the subclavian to its junction with the internal jugular, labeled *m*. The advance made in around fifteen years from the very inaccurate representation of these veins in the first drawing of this exhibition is self-evident.

The old man with covered head sketched at the top of the page may well have been the subject of dissection. His leanness would be a valuable feature to Leonardo, who repeatedly stressed its importance for anatomical work. Only in lean bodies are the superficial veins and muscles of the chest and upper arm easy to display so well as Leonardo has illustrated them here.

The three drawings of the muscles and shoulder of the right arm are related to those on the other side of this sheet. They show the muscles after the skin and veins have been removed.

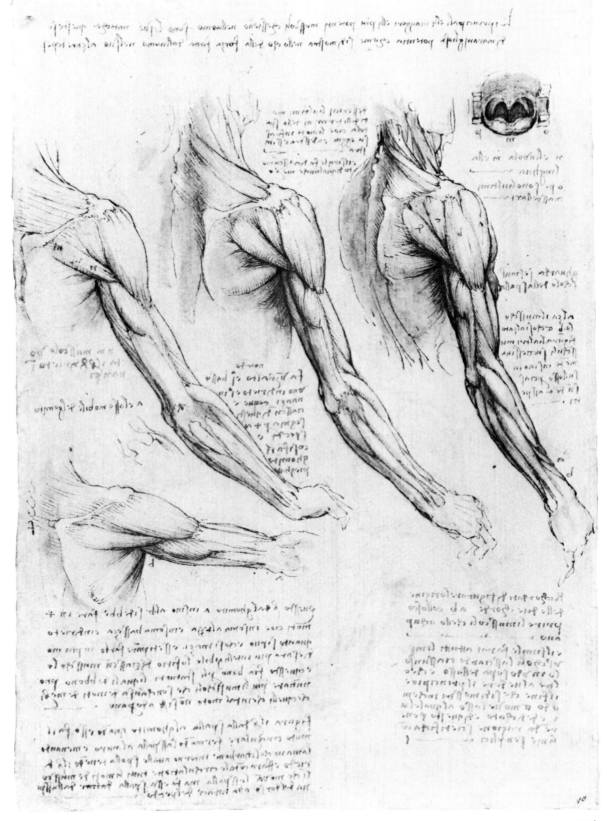

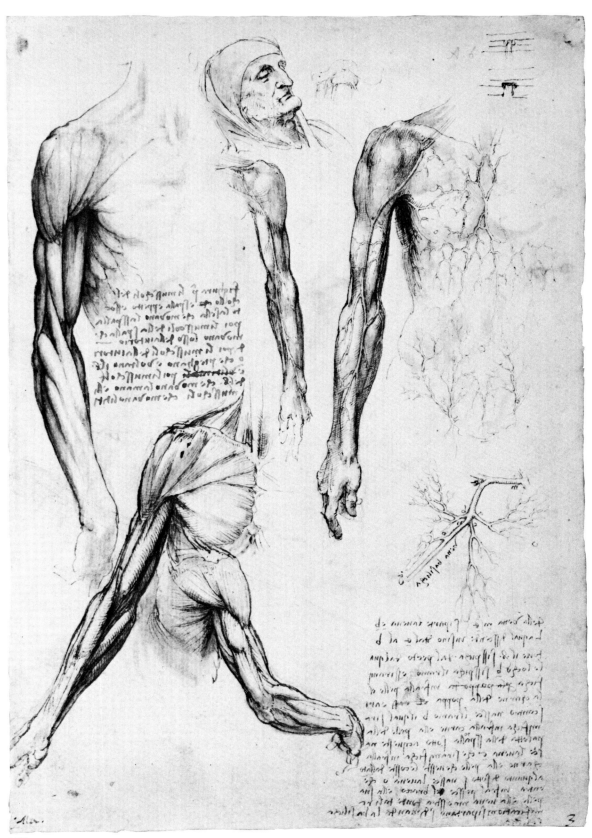

26A. Muscles of the right arm, shoulder, and chest

Pen and brown ink with wash modeling over traces of black chalk, with small red chalk strokes between the main figures. 288 × 202 mm (R.L. 19008v)

The main drawings on this page continue the series of different aspects of the arm and chest begun in 25A, as a man is rotated 180 degrees into eight positions. Many of the muscles are lettered and their actions described. In the corner bottom right is a diagram of an eight-pointed star around which Leonardo writes: "I turn an arm into eight aspects of which three are from outside, three from inside, and one from behind, and one from the front. And I turn it into eight others when the arm has its two fociles [radius and ulna] crossed [i.e., in pronation]." Drawings representing the intention expressed in the latter part of this diagram do not appear to have survived.

The notes covering the lower part of the sheet are concerned entirely with the nature of muscles. Leonardo asks himself questions such as, "What are the muscles that are never hidden by fat or fleshiness?... What are the muscles that are united in men of extraordinary strength?... What are the muscles that are divided in lean men?"

At the top of the page are three studies, labeled (from right to left) "first, second, and third demonstrations, of the muscles of the cervical spine." These are further developed in R.L. 19015R, where the combination of muscles for stabilizing the vertebrae (left and central diagram), and muscles for bending them to one side (right-hand diagram) is applied to the whole spine.

26B. The bones of the leg

Pen and brown ink with wash modeling over traces of black chalk. (R.L. 19008R)

We do not know how Leonardo prepared the bones of skeletons for study, but the bones in this drawing bear witness to the success of his technique. In the top row of drawings Leonardo draws legs according to his principles from three aspects: side, back, and front. The foot of the first drawing, that on the right, receives special attention as a lever. Leonardo writes: "Note here that the tendon that takes hold of the heel *c* [tendo calcaneus or tendo Achillis] raises a man on the ball of his foot *a*, the weight of the man being at the fulcrum *b* [the internal malleolus of the ankle]. And because the lever *b–c* enters twice into the counterlever *b–a,* 400 pounds of force at *c* produces a power of 200 pounds [the weight of a man in Florentine pounds] at *a* with a man standing on one foot." This is good biomechanics.

In the kneeling figure at the center of the lower row he shows how the muscle cords *a–b* and *n–m* produce rotation of the lower leg at the knee when it is bent, in contrast to their action when the knee is straight, as shown in the central figure of the upper row. Leonardo comments that the "patella has less sensation than any other bone in man."

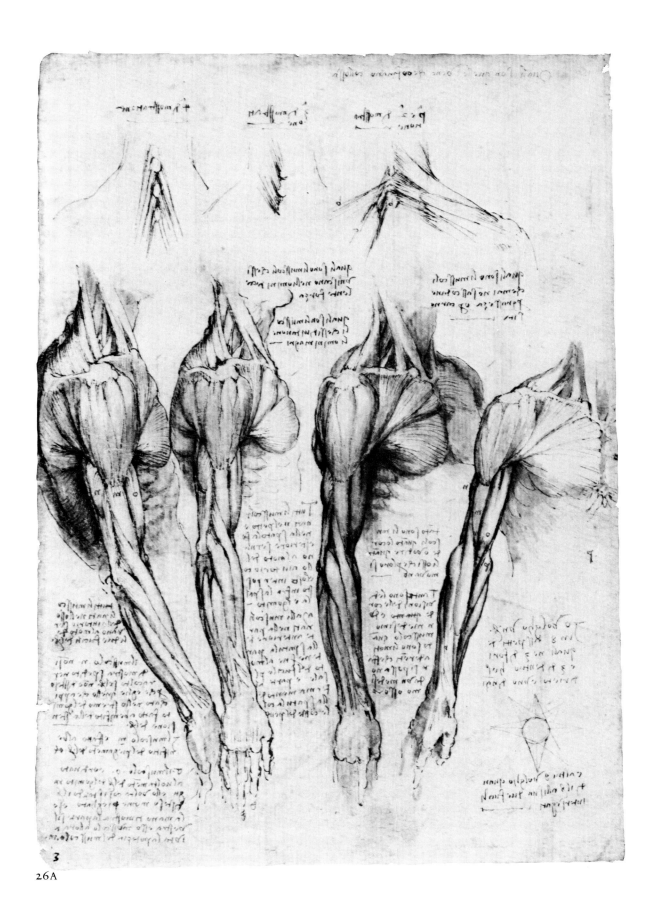

3

26A

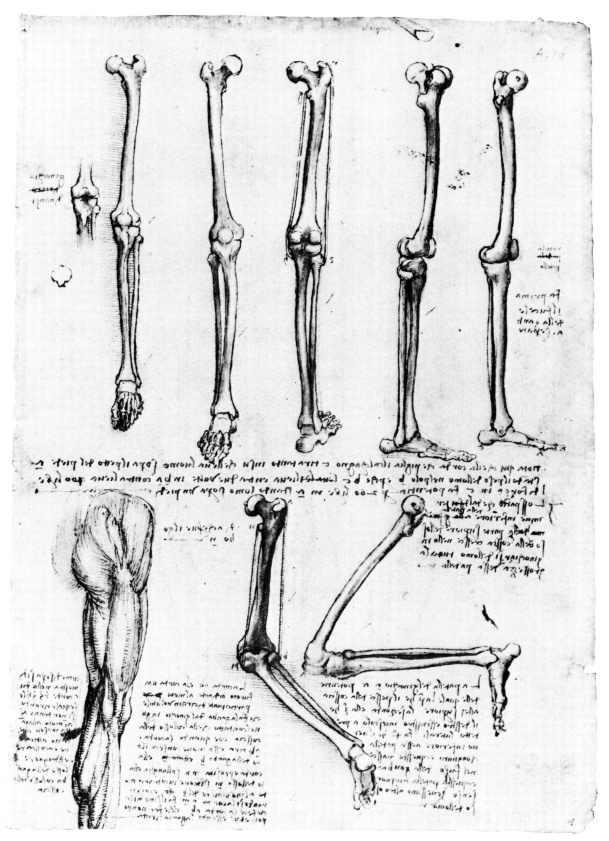

27A. *The surface muscles of the neck and shoulder*

Pen and brown ink (two shades) with wash modeling over traces of black chalk. 292 × 199 mm (R.L. 19003R)

F. A. 4R

c. 1510

In this set of drawings of the neck and shoulder Leonardo reviews the surface markings of muscles before removing the skin for superficial dissection, as seen on the verso of this sheet, 27B.

The text is partially concerned with the intermediary stage, that is, the depiction of the superficial veins as seen on 25B and suggested in the small diagrams center left and bottom right. Top left are two notes: "On the nature of veins" and "On the number of veins." On the first of these issues Leonardo writes: "The origin of the sea is contrary to the origin of the blood because the sea receives into itself all the rivers, which are caused solely by the aqueous vapors raised up into the air. But the sea of the blood is caused by all the veins."

The remaining text is concerned chiefly with neck movements as illustrated by the accompanying illustrations of the neck and shoulder from a variety of viewpoints. The long note on the right describes the movements of the neck: "The neck has four movements. The first to raise the face, the second to lower it, the third to turn it to the right and left, the fourth to bend the head to the right and left." Other movements he calls "mixed." He ends by emphasizing the importance of the knowledge of the muscles performing these movements "so that if a man through some wound should lose one of these movements one will be able to understand with certainty which tendon or muscle is damaged."

The man's head and shoulders, top center, were engraved by Wenceslaus Hollar in 1648, when the drawing was in the collection of Lord Arundel.

27B. *The muscles of the shoulder*

Pen and brown ink (three shades) with wash modeling over black chalk. (R.L. 19003V)

F. A. 4V

c. 1510-13

In these drawings Leonardo illustrates the mechanics of the movement of the shoulder joint. He approached this problem by dissection at ever deeper levels from the skin down to the articulating bones. In the dissection top left the actions of pectoralis major, teres major and minor, levator scapulae, supraspinatus, infraspinatus, latissimus dorsi, and the rhomboid muscles all claim his attention, and each is labeled with a letter. The pectoralis major was divided by him into fasciculi that represent the lines of force along which the muscle acts.

Leonardo carried this schematic representation to its logical conclusion by representing all the muscles of the shoulder joint by their lines of force, as cords, in the figure on the right margin. Thus he reduced the forces acting on the joint to an intelligible geometrical and mechanical pattern, according to the following scheme: "Before you form the muscles, make in their place threads that should demonstrate the positions of these muscles; the ends of these [threads] should terminate at the center of the attachments of the muscles to the bones. And this will give a clearer knowledge when you want to draw all the muscles, one on top of the other; and if you do it otherwise your drawing will be confused."

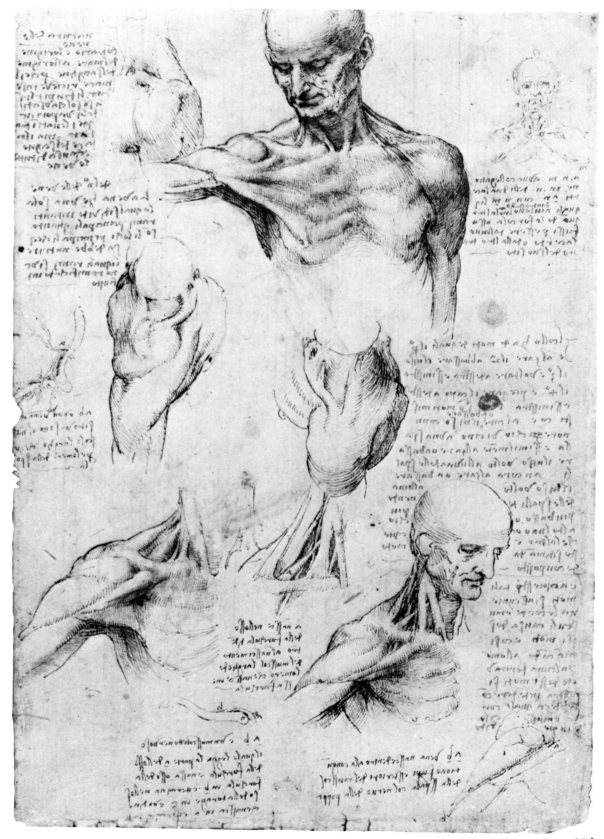

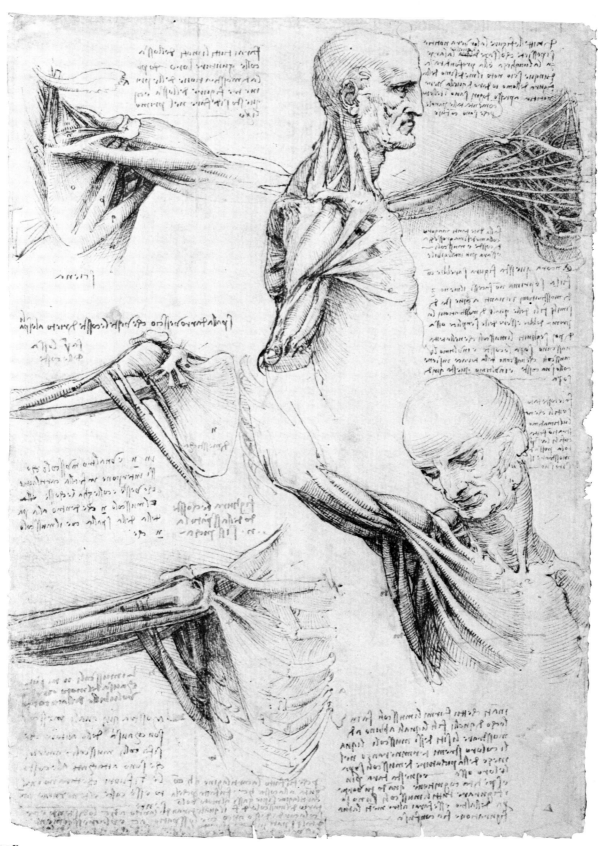

Cf 49 (O'Malley)
(Clark 19013v)

28A. The muscles of the trunk and legs

Pen and brown ink (two shades) with wash modeling over black chalk. 286 × 207 mm (R.L. 19014v)

The full-length figure on the right illustrates the superficial muscles of the trunk and thigh. Most noteworthy in the trunk are the interdigitations of serratus anterior and the external oblique muscles of the abdomen on the ribs. Leonardo's text, however, concentrates on the muscles around the hip joint, the horizontal axis of the body: "The axis, *n,* is always found in well-proportioned men opposite the fork of the thighs." Once more tensor fasciae latae *a* is seen joining the vastus lateralis *e.* The other muscles *b, c,* and *d* are the subdivided gluteus medius and gluteus maximus, the muscles forming the buttocks. Considering that Leonardo calls the muscles of the buttocks "the principal and most powerful muscles in man" (25A), he has given them here a surprisingly feeble representation. He comments: "When the muscles *a* and *r* [tensor fasciae latae and sartorius] pull on the leg, it is raised forward; and the two muscles *b c* [gluteus medius] are relaxed, and *d* [gluteus maximus] is elongated. Describe this rule in the operation of all muscles and you will be able to make out, without seeing the living, almost every action without exception."

The central figure shows once more the pattern of tensor fasciae latae, sartorius, and the rectus femoris. The small figures above form part of a study of the blood and nerve supply of muscles, and on the left margin unidentifiable muscles are placed over the ribs.

28B. Muscles of the thigh

Pen and brown ink with wash modeling over black chalk. (R.L. 19014R)

On this page Leonardo advocates making his demonstrations on bodies with lean muscles "so that the space which appears between one and the other makes a window to demonstrate what is behind them—like this drawing of a shoulder made here with charcoal." The accompanying drawing of the shoulder and extended right arm, though faint, gives a good impression of the view in depth so obtained, and further simplified by representation as a "cord diagram" (see 27B).

The forceful muscular figure below suggests that exaggeration of muscle outlines that Leonardo adopted at the period of the *Battle of Anghiari* cartoon (1503–5). All through his life Leonardo looked on the tensor fasciae latae with sartorius as the main flexor muscles of the hip joint. He failed to find the psoas and iliacus muscles. Here tensor fasciae latae, labeled *b,* is seen joining the vastus lateralis, labeled *a,* on the outer side of the thigh, while sartorius, arising also from the anterior superior iliac spine, runs like a strong strap to the inner side of the left knee. Between the two is rectus femoris going to the kneecap. The notes discuss the action of muscles and the distribution of fat in muscular men.

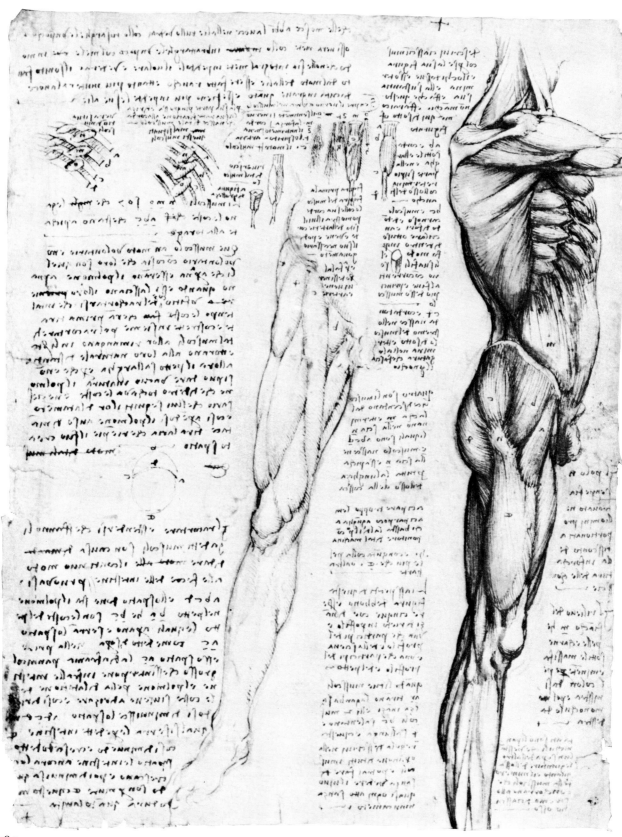

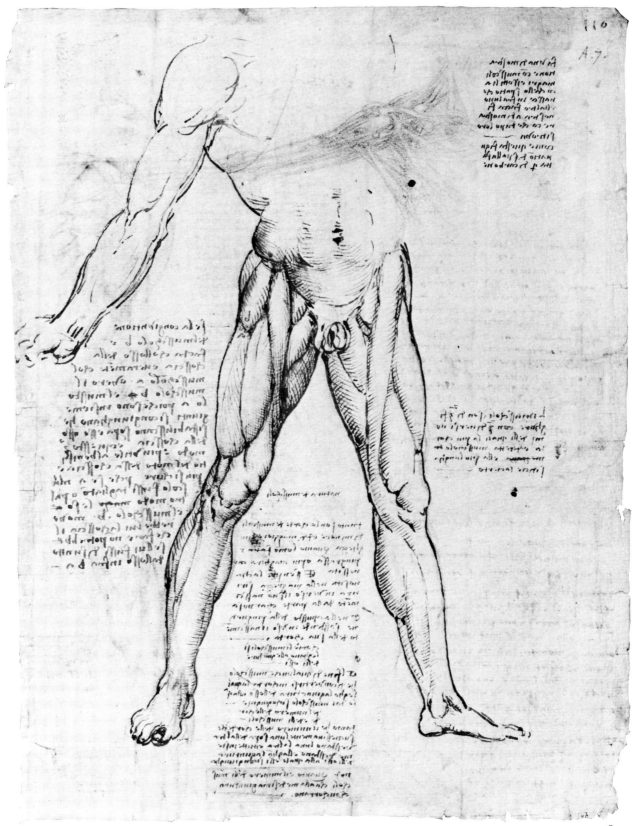

29A. The larynx and trachea and muscles of the left leg

Pen and brown ink (three shades) with wash modeling over black chalk, and red chalk doodle top right. 290 × 196 mm (R.L. 19002R)

Here most of the drawings show the larynx and trachea. Particular attention is paid to the epiglottis, and in the drawings down the right-hand margin this is shown in various positions. The second drawing from the top shows a food bolus passing over the epiglottis, bending it back and so closing the entrance to the larynx. The thyroid gland is shown as a rather pendulous bilobed structure, hanging down in front of the upper rings of the trachea. Leonardo described it as being "made to fill in where muscles are lacking; they keep the trachea apart from the clavicle" — a view in keeping with Galen's ideas as to the function of glands as mechanical padding.

The drawings bottom center show the vocal cords. Leonardo thought that sound is formed by the vocal cords much in the same way that it is in a flute, that is producing eddies in the air from the lung as it flows over them. He represents them, and the hollows between them known as the ventricles of Morgagni, accurately. They aid in making eddies of air in voice production. Scattered all over this page are notes of Leonardo's queries and conclusions, chiefly with relation to the formation of sound; these were added over a period of years to fill every available space on the sheet. "Why does the voice become high pitched in old men?" Answer: "Because all the passages of the trachea are narrowed in the way that other entrails are." And again, "See how the sound of the voice is generated at the head of the trachea. This will be understood by separating from a man the trachea with the lung; which lung filled with air and then suddenly pressed will immediately enable one to see how the fistula of this trachea generates the voice. And this will be seen and heard well with the neck of a swan or a goose, which is often made to sing after it is dead."

29B. The bones of the foot and dissections of the neck

Pen and brown ink (two shades) with wash modeling over black chalk. (R.L. 19002V)

The studies of the foot from above are in the same series as 31B and 33A. Leonardo often used an "exploded" view to explain joints. The rough diagram of a skeleton top right is shown with most of its joints separated. Below it he refers to this method, saying, "Break or disunite each bony joint from one another." He made an erroneous trial of the method on the ankle joint to the left. See 33A for a more successful effort. The small diagram upper left is labeled: "a b are the two lateral movements of the toes," and the central drawing of the bones of the foot from below has the comment: "Note what service the rounded prominences a b c [the sesamoids] render; and also all the other shapes of the bones." These "prominences" form the groove for the tendon of peroneus longus (c) with tuberosity (b) behind. Elsewhere on the sheet Leonardo remarks: "The pieces of bone of which the foot of man is composed are twenty-seven."

The dissections of the neck in the lower three figures show Leonardo delving ever deeper into this region. The sternomastoid in the first two figures divides the neck into its anterior and posterior triangles. In the third figure this muscle has been removed to show the complexity of the muscles beneath. The left-hand figure was engraved by Wenceslaus Hollar in the seventeenth century.

The diagram on the right margin shows Leonardo's mastery of the subtle pair of muscles named digastric (two-bellied), which run backward from the chin.

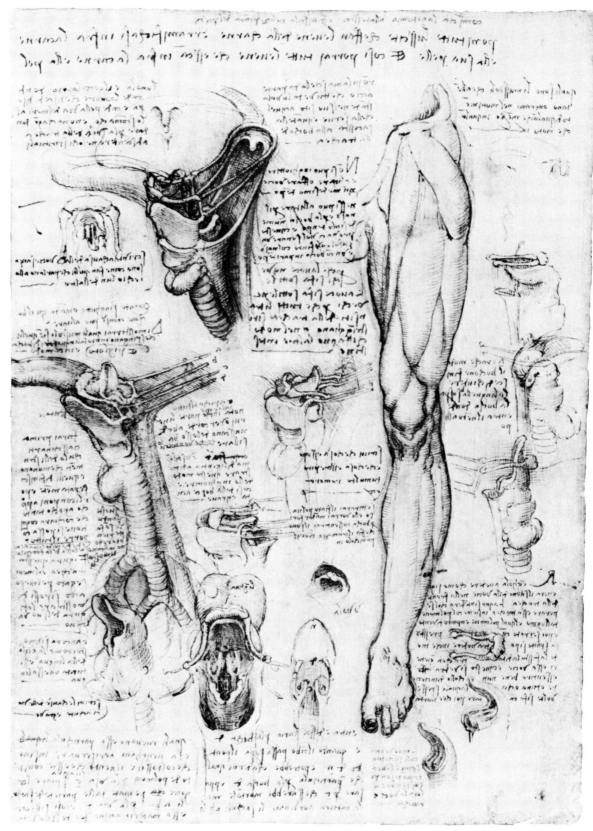

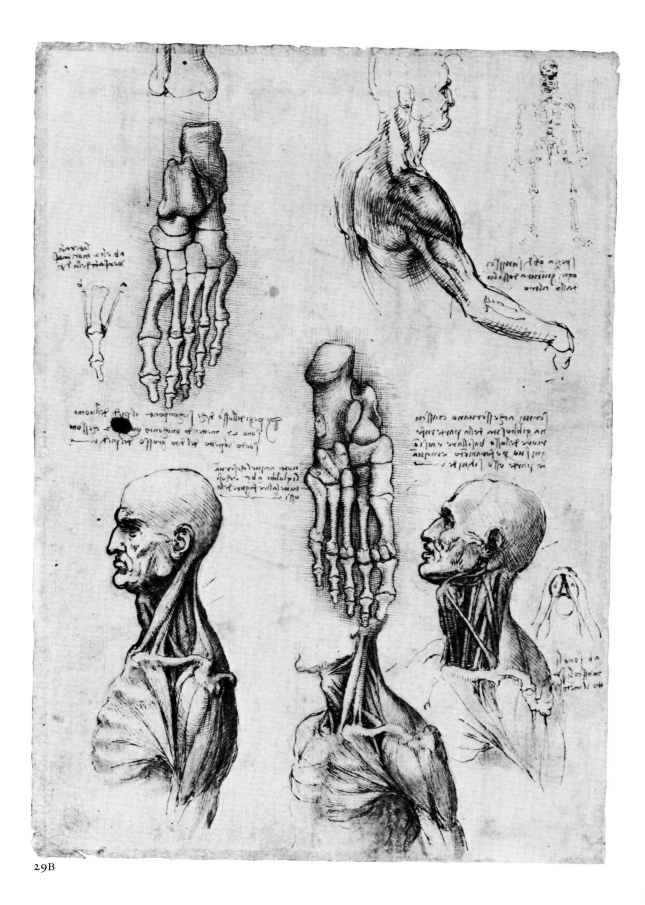

29B

30A. The skeleton of the trunk and legs

Pen and brown ink (three shades) with wash modeling over traces of black chalk. 288 × 200 mm (R.L. 19012R)

The drawings on this page represent the most comprehensive set of illustrations of the human skeleton to be found among Leonardo's drawings. The rib cage and bones of the upper arm and shoulder are shown from the side (top right), back (top left), and front (bottom left). Beside the first of these drawings Leonardo comments: "From the first rib, *a*, to the fourth below, *b*, is equal to the scapula of the shoulder *cd*; and is similar to the palm of the hand and to the foot from its fulcrum to the point of this foot; and each is similar to the length of the face." Around the figure, bottom left (in which Leonardo erroneously follows Mondino in depicting the sternum with seven segments) the artist makes various observations about the shoulder joint.

The group of drawings of the leg and kneecap, bottom right, belong to the same series as those on 26B. In these Leonardo clearly shows his appreciation of the action of the patella as a sesamoid bone. In the figure second from the right he shows it flopping forward with its tendon hanging down below, and farther to the left, in the center of the sheet, it is shown separately.

The notes are chiefly concerned with the shoulder joint, but the sheet is headed by two lines, as follows: "What are the parts of man where the flesh does not ever increase through any fatness; and what are those places where the flesh increases more than anywhere else." A quarter of the way down the left-hand edge is an enumeration of the "bones" of the head and jaws. In this case it reads: *testa 1* (one head), *masscella 2* (two jaws), *denti 32* (thirty-two teeth).

30B. The muscles of the arm, hand, and face

Pen and brown ink (three shades) with wash modeling over traces of black chalk. (R.L. 19012V)

On this page Leonardo deals with four related subjects. First, in the note across the top of the page, he attempts to classify muscles according to the shapes and attachments to bone by their tendons of origin or insertion.

Secondly, he considers once again the superficial muscles of the arm, paying particular attention to the fascicles of the deltoid (see also 25 A and B and 26A).

Between the two drawings of the right arm are two figures showing the muscles of expression in the face. The drawing on the right shows the structures revealed by "lifting off" the more superficial muscles. The different muscles are labeled in more detail in the left-hand drawing, as follows: "*h* is the muscle of anger, *p* is the muscle of pain, *g* is the muscle for biting, *g n m* is one and the same muscle [for biting], *o t* is the muscle of anger." Leonardo appears to show the muscles of anger and pain (*h* and *p*) situated over the superciliary arch to right and left. These are clearly identifiable as the corrugator, which draws the eyebrows downward and inward, producing vertical wrinkles, expressive of both anger and pain. In studying the facial muscles, Leonardo looked first at those of the horse, "which has large muscles and very clearly seen parts." Several of Leonardo's drawings connected with the Anghiari project (e.g., R.L. 12326R and 12327R) show the expressions of anger or fright, with the wrinkled brow and upcurled lip, in man alongside those of the horse.

The fourth subject considered on this page is the muscles and arteries of the hand, which are continuous with those on 32A and B. The accompanying notes contain observations such as the following: "Have you seen here the diligence of nature in having placed the nerves, arteries, and veins at

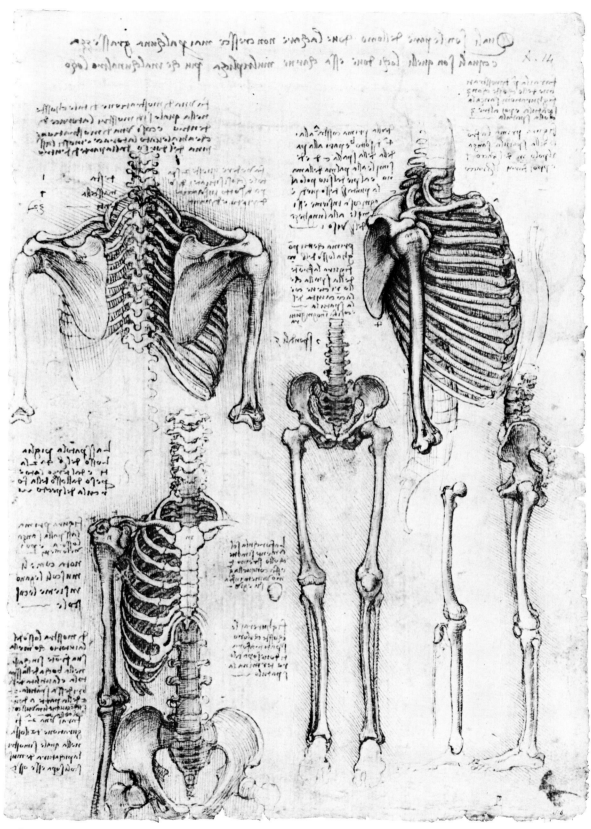

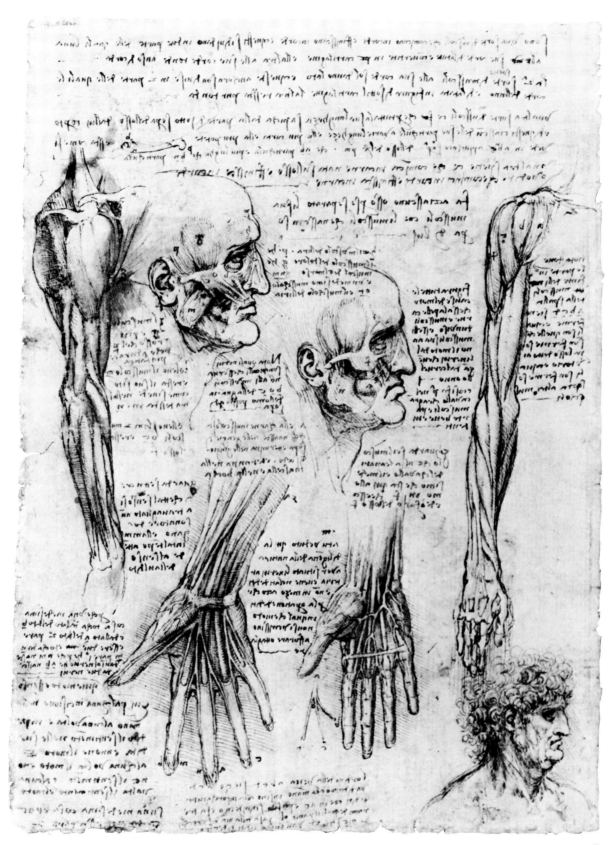

the sides of the fingers and not in the middle, so that in the operation of the fingers they do not in some way get pierced or cut." Leonardo also notes how one object felt with crossed fingers feels like two, an experiment also described on 32B.

31A. Arm movements made by the biceps

Pen and brown ink (two shades) with wash modeling over traces of black chalk. 291 × 200 mm (R.L. 19000V)

These drawings illustrate Leonardo's method of demonstrating the action of muscles by displaying them on the bare levers of the bones that they move. Here the action of the biceps on the elbow joint is studied from various points of view. Its two heads (bi-ceps) are shown in the drawings, often cut, with a slip (usually lettered) to show how it is inserted into the radius of the forearm in such a way that it rotates that bone and the hand it carries so that "the palm faces the sky," i.e., is supine.

In the lower two drawings he shows how the "palm is turned toward the ground" (pronated), and in the lowest study he draws the muscle that does this, the pronator teres. This discovery that the biceps rotates the hand as well as bending the elbow was a source of great joy and pride to Leonardo, who made numerous drawings of the subject (see also 37A). It was not repeated until some two hundred years later, by Cheselden.

The seven lines of writing above the lower arm and hand of the central figure contain one of Leonardo's numerous notes, applicable to human anatomy in general:

> The true knowledge of the shape of any body whatever consists of seeing it from different aspects... in order to give knowledge of the true shape of any limb of man, first of beasts among animals, I will observe the aforesaid rule, making four demonstrations of each limb from their four sides; and of the bones I will make five, sawing them along the middle and showing the empty space [marrow] in each of them of which one is medullary, another spongy, either empty or solid.

31B. The bones of the foot and surface muscles of the shoulder and neck

Pen and brown ink (two shades) with wash modeling over traces of black chalk. (R.L. 19000R)

The drawings of the bones of the ankle and foot show a detailed knowledge of their anatomy. They are closely connected with those on 29B and 33A. In the figure top left the bones of the left ankle and foot are drawn from behind, with the tibia and fibula added separately above. The central figure shows the bones of the right foot ("in the same direction" as before, "to make it more intelligible") now seen from below and in the bottom figure (upside down) from the side.

In the notes Leonardo concentrates on the sesamoid bones beneath the ball of the great toe (labeled r on the lower figure), through which the tendon acts. The little sketches above study "the power of the line of movement passing through the junction of movable bodies" such as this joint. Leonardo concludes: "Nature has placed the glandular bone (sesamoid) under the joint of the great toe of the foot because if the tendon to which this sesamoid bone is joined were without the sesamoid it would receive great damage in the friction made under so great a weight as that of a man walking, when at each step he raises himself on the ankles of his feet."

The drawing of the surface markings of the superficial muscles of the shoulder and upper arm (top right) is found with variations on several occasions, for example on 20B. Both appear to be shaded from right to left, which is unusual for Leonardo, who was left handed.

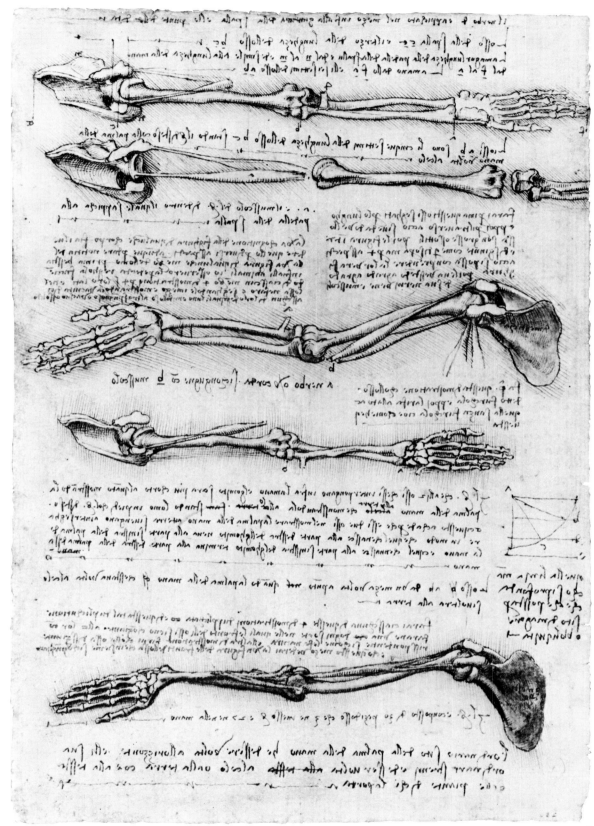

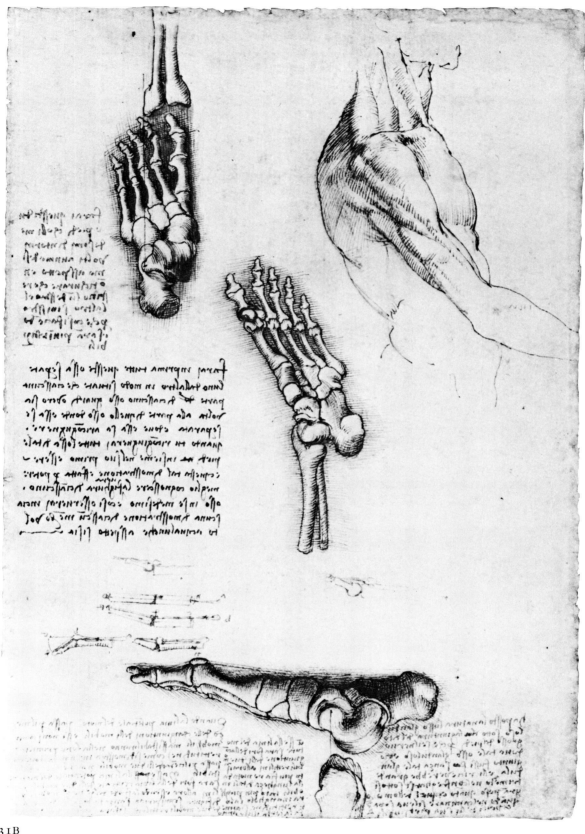

32A. Bones of the hand

Pen and brown ink (two shades) with wash modeling over traces of black chalk. 288 × 202 mm (R.L. 19009v)

The sheet is headed "Representation of the hand," and in the eight-line note across the top of the page Leonardo proposes eight separate demonstrations of the hand: of the bones, the ligaments, the muscles, the deep tendons, which "give movement to the tips of the fingers," the second stage of tendons of the fingers, the nerves, the veins, and arteries, and lastly the hand clothed with skin. "These separate operations should be carried out on an old man, a young man, and a child, noting the length, thickness, and breadth in each case." The drawings on either side of this sheet go some way toward providing illustrations of each of these stages. They are notable for being the first of their kind for accuracy, particularly in the representation of the separate bones of the wrist. According to his principles of demonstration, Leonardo draws the parts from the back (left), front (right), and both sides (bottom).

On the right margin are beautiful studies of the tendons of a finger, each carefully labeled: "*a* is the cord that straightens the bent finger [i.e., extensor digitorum]; *e* is the cord that bends the straight finger [i.e., flexor digitorum]; . . . *c* is the nerve that gives sensation. This having been cut, the finger no longer has sensation even when placed in the fire." Leonardo's phraseology reminds one that in his time these structures had no names. The small sketch below these notes shows how the flexor tendons stand out with a clenched fist.

32B. Dissection of the hand

Pen and brown ink (three shades) with wash modeling over traces of black chalk. (R.L. 19009R)

Following the precepts laid down at the top of 32A, the drawings on this page show the bones and muscles of the fingers and hand at various depths. The sequence is continued in the two drawings of the hand on 30B. The upper drawings here illustrate the course of the flexor tendons of the fingers at the wrist crossing the palm of the hand to their insertions in the phalanges. A careful study of the exact mode of insertion is made in the small central figure—the flexor digitorum profundus tendon being shown piercing that of the flexor digitorum sublimis. The action of these tendons in bending the finger is shown in the two small figures bottom right. A deeper dissection of the small muscles of the hand lies to the left of this, and finally on the left are the bones of the wrist and hand.

The text consists mostly of precepts on how best to illustrate the various parts of the hand in "ten demonstrations." Leonardo suggests the building up of a cord diagram, similar to that of the shoulder on 28B. "When you have drawn the bones of the hand and wish to draw on this, the muscles that are joined with these bones, make threads instead of muscles. I say threads and not lines in order that one should know what muscles go below or above another muscle, which cannot be done with simple lines. And having done this then make another hand alongside this one where the true shape of these muscles is shown as is demonstrated here above." Over the central upper figure Leonardo writes: "Make the book on the elements and practice of mechanics precede the demonstration of the movement and force of man and other animals, by means of which you will be able to prove all your propositions."

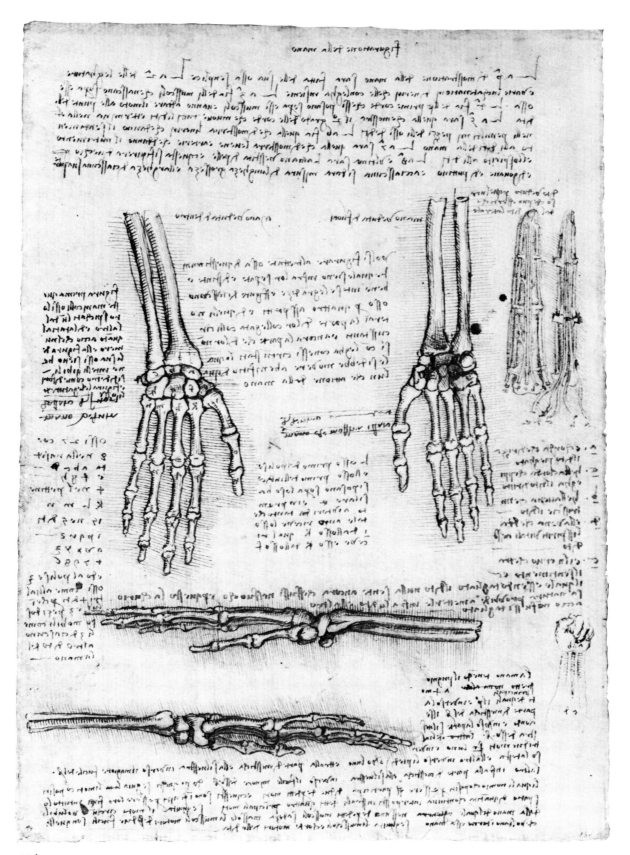

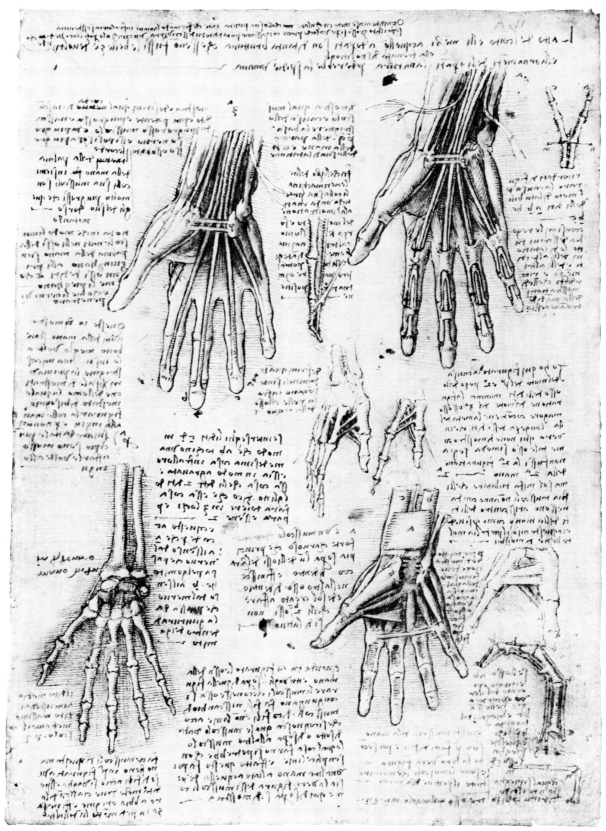

33A. Bones of the foot and shoulder

Pen and brown ink (two shades) with wash modeling over black chalk. 287 × 198 mm (R.L. 19011R)

These magnificent drawings of the bones of the foot form part of the series to be found on 29B and 31B. It is curious that Leonardo's drawings of the foot frequently coincide with studies of the shoulder, as in this instance, where the drawing top center shows a deep dissection of the shoulder joint.

The text is concerned with making "six aspects of the foot" with "separated bones," etc. The sesamoid bones, seen joined to their tendons bottom left, receive detailed consideration as to their number and situation throughout the body. The anatomist finds eight sesamoids in the body: two in the shoulders (acromial processes), two at the kneecaps, and four in the feet (two beneath each big toe). For further discussion of the kneecap, see 26B and 30A.

33B. Muscles of the forearm

Pen and brown ink. (R.L. 19011V)

The two splendid upper drawings of the arm with the hand grasping a staff show the close link between Leonardo's scientific and artistic activities. The superficial anatomy of the muscles and veins in the uppermost drawing will bear inspection from any anatomist, as will the deeper dissection of the lower figure. Below are two less-finished drawings of the muscles of the outer arm and neck, views that are further developed in 26A and other drawings.

The text at the bottom compares the movement of a man's arm with that of a bird's wing: the wings of a bird "are so powerful because all the muscles that lower the wings arise in the chest; these have in themselves greater weight than all the rest of the bird."

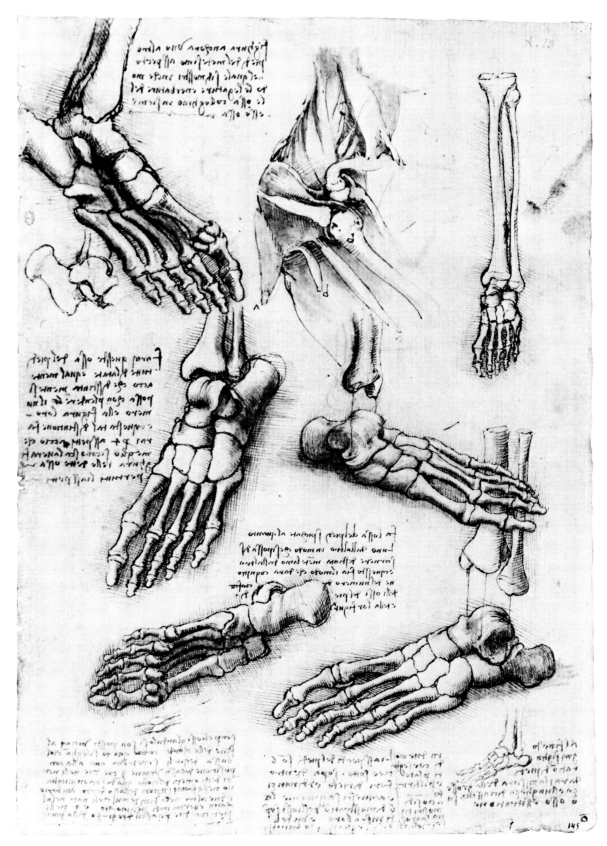

X. 13

145

120

33A

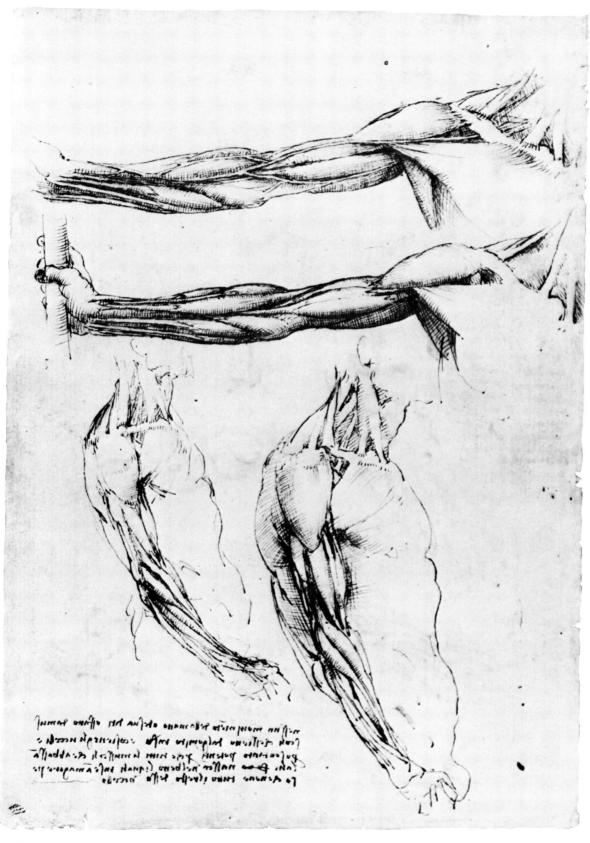

THE HEART

Leonardo worked in detail on the heart only during the last years of his life. The five pages of drawings in this section are all on the same blue paper and belong to a group of drawings at Windsor, one of which is dated 9 January 1513. All the drawings depict dissections of an ox's heart, rather than that of a human.

The ideas concerning the heart held by Leonardo's mentors (such as Galen and Mondino) taught him that the heart consisted of two ventricles, separated by the interventricular septum; the auricles were according to this idea no more than appendages to the veins. Leonardo came to dispute this view, as he did the idea that blood heat was innate (35B).

In his examination of the operation of the heart Leonardo made constant reference to his experiments on the flow of water. When building canals he discovered that eddies are formed when water emerges from a narrow channel to a wider one, and he now applied this knowledge to the passage of blood through the valves of the heart. He concentrated his researches particularly on the aortic valve and built a model of the aorta with its cusps to study the flow of water (and so of blood) through it (38). Nevertheless, he never got as far as disputing the medieval idea that blood constantly flows to the periphery through arteries and veins, and, contrary to what has frequently been stated, he did not discover the circulation of the blood.

34. *The heart and lung*

Pen and brown ink (two shades) on blue paper. 287 × 203 mm (R.L. 19071R)

On this page the divisions of the trachea into its bronchi are shown, these branches being accompanied by the bronchial arteries shown arising from the aorta. Leonardo describes both the bronchial and pulmonary arteries, and discusses why nature duplicates the blood supply to the lung: "Nature gave the trachea such veins and arteries as were sufficient for its life and nourishment and somewhat removed the other large branches from the trachea to nourish the substance of the lung with greater convenience" (the word "trachea" is used here to describe the whole bronchial tree).

To the right of the main drawing there are two small figures, shaped like dividers, of the trachea minima, or smallest bronchi, shown dilated as in inspiration and narrowed as in expiration. The trachea, with particular reference to the elasticity of its rings, is represented farther to the right, at the edge of the page. At the bottom of the lung Leonardo has placed the letter *n* in a circle, with a line running from it to a passage which reads: "Nature prevents the rupture of the ramifications of the trachea by thickening the substance of this trachea and making thereof a crust, like a nutshell, and it is cartilaginous and this with such a hardness as a callous repairs the rupture, and in the interior remains dust and watery humor." In these words Leonardo makes one of the earliest descriptions of a tuberculous cavity in the lung.

The long passage down the upper left-hand side of the sheet is another outcry by the artist in favor of visual rather than verbal description of the anatomy, as in 20A:

> Oh writer, with what words will you describe with like perfection the entire configuration as the design here makes? This you describe confusedly, having no knowledge, and you leave little knowledge of the true forms of the things, which you, deceiving yourself, make believe to satisfy fully the auditor, having to speak of the configuration of any corporeal thing surrounded by superficies. But I remind you not to involve yourself in words, if you do not speak to the blind; or if nevertheless you will demonstrate with words to the ears and not to the eyes of men, speak of substantial or natural things and do not meddle with things appertaining to the eyes, making them enter by the ears, as you will be by far surpassed by the work of the painter. With what words will you describe this heart so as not to fill a book, and the longer you write, minutely, the more you will confuse the mind of the auditor, and you will always be in need of the commentators or of returning to experience which is with you very short, and gives knowledge of few things relating to the whole of the subject of which you desire entire knowledge.

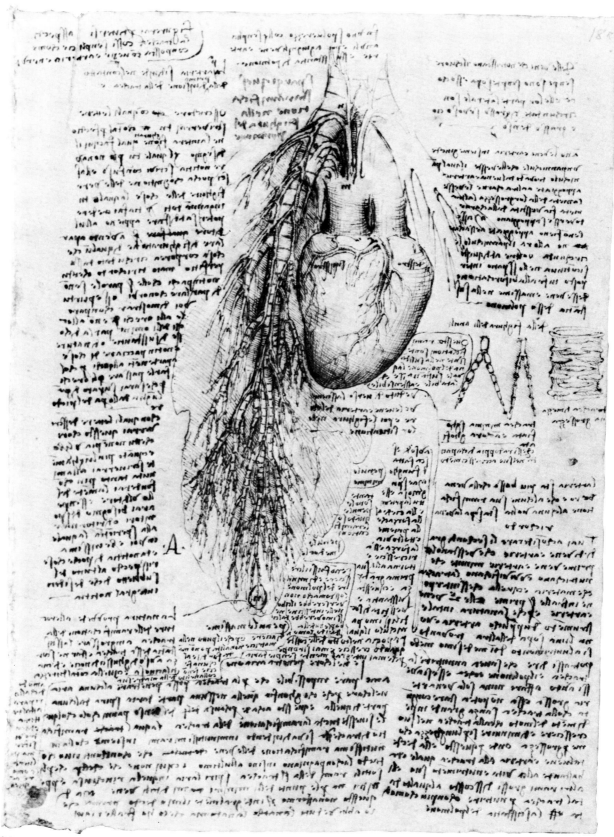

35A. Superficial veins of the heart

Pen and brown ink on blue paper.
291 × 414 mm (R.L. 19073–74v)

This sheet was formerly folded down the middle, with 35B as the outer side.

The two main figures on the left-hand side of the sheet show an ox's heart seen from two viewpoints, in each case with the root of the pulmonary artery severed. To either side of this can be seen the two coronary arteries, marked *a* and *b* in the diagram on the right, arising from the aorta. Behind the aorta are the posterior vena cava pulled upward and the anterior vena cava.

Above these are diagrams of the interventricular septum of the heart, with the lateral walls of the ventricles displaced. The septum was of great. importance in the Galenical system, since it was through its pores that some of the blood that ebbed and flowed in the right ventricle passed to become refined or subtilized in the left ventricle as the vital spirits distribute the vital body heat. Leonardo notes in the top left-hand corner:

> The blood subtilizes itself more where it is more beaten, and such beating is made by the flux and reflux of the blood produced by the two internal ventricles of the heart to the two external ventricles, named auricles or appendices of the heart, which dilate themselves and receive into themselves the blood, driven from the internal ventricles; and then they contract themselves, giving back the blood to these internal ventricles. And the internal muscles, apt to contract, are of one and the same nature in the four ventricles; but the external muscles are only for the internal ventricles of the heart, and for the external ones they form only one continuous coating, dilatable and contractable.

The drawings over the right-hand side of the sheet show the heart from other viewpoints and with other vessels severed for greater clarity. The small figures in the middle of the right-hand margin show the ring of blood vessels surrounding the top of the heart like a crown, well illustrating the origin of their name, "coronary" arteries. Beneath them near the right margin Leonardo writes: "The heart seen from the left side will have its veins and arteries crossing like somebody crossing his arms; and they will have above them the left auricle and inside them the gateway of triplicate triangular (i.e., aortic) valves; and this gate remains triangular when open." Below these words he draws two aortic valves, that on the right with the caption *ap[er]ta* (open), and that on the left *serrata* (closed).

35B. The ventricles of the heart

Pen and brown ink on blue paper.
(R.L. 19073–74R)

The drawings on the left side of the page show the heart in transverse section, with the "sieve of the heart" (septum) lying between the right ventricle above and the left ventricle below; the figure bottom center represents the same heart in longitudinal section. The two drawings across the center of this side of the sheet show on the right the heart in diastole, and on the left the heart in systole. The papillary muscles, which according to Leonardo prevent the ventricles from shutting completely, are seen in both the drawings on the left and in the lower of the two drawings on the right, where they bulge into the left ventricular cavity. Above the lower drawing Leonardo has labeled (from left to right) the positions of the pulmonary artery and orifice at *b,* the vena cava with vestigial right auricle at *d,* the aorta and aortic orifice at *a,* and the pulmonary vein with vestigial left auricle at *c.* He comments that the valves at *a* and *b* open outward while those at *c* and *d* open inward for the outflow of blood. The force of blood at *c* and *d* is taken

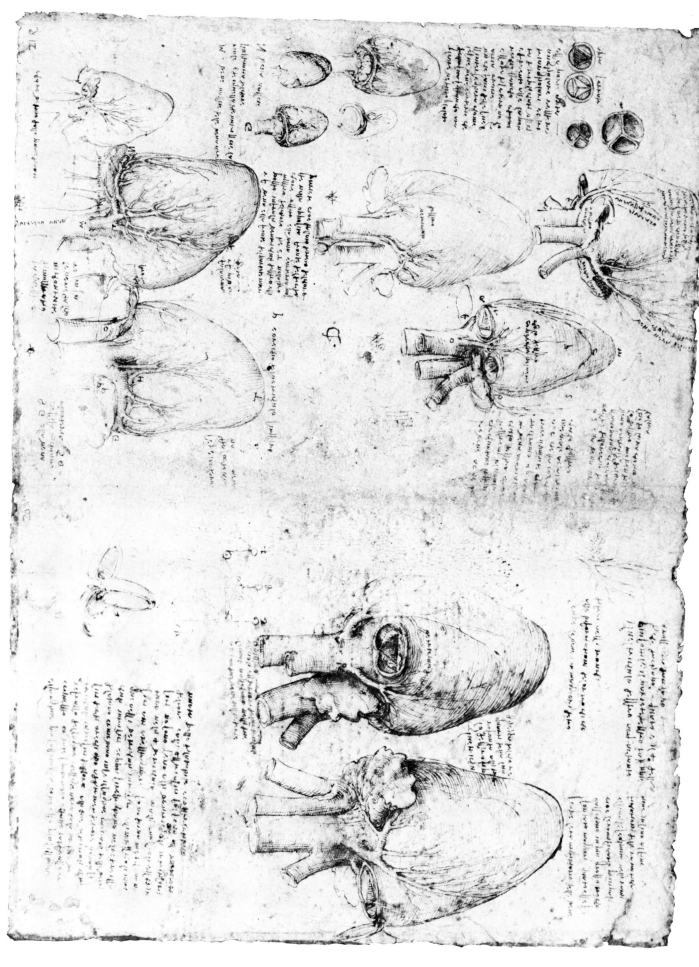

by the auricles, whose dilation "is the reason why the percussion that the impulse of the escaping blood produces in them, is not of too great power." A further explanation concerning the heartbeat is seen in the faint figure bottom left of the fold, showing a rod $a-b$ balanced at the point c on a circular object. The heartbeat upsets the balance of the rod and creates the "accidental lightness" of Aristotelian terminology. The accompanying notes on this side of the sheet relate to the muscles of the heart and the method by which the blood is heated. It was formerly held that the blood heat was innate, but Leonardo stated that the heat was built up through the friction produced by the blood passing from the contracting atria into the ventricles and back again.

The drawings on the right side of the sheet are chiefly dissections of the tricuspid valve, which is opened out to show its sides (above, and just below center) and the papillary muscle, seen from one side opened out (upper right) and greatly foreshortened (lower center).

36. *The ventricles of the heart*

Pen and brown ink on blue paper.
284 × 209 mm (R.L. 19080R)

The drawings on this sheet are continuous in content with those on 35A and B. The preparation of the heart for the cut that revealed the interventricular septum seen in the small diagram on 35A is shown down the upper left-hand margin in four diagrams labeled 1–4.

The drawings across the center of the sheet depict the left ventricle with the mitral valve (above and to the left) and papillary muscles, from which the chordae tendineae arise. These drawings, with almost architectural columns and vaulting, were specially designed by Leonardo to illustrate his thesis that the cusps of the mitral valve are formed from a fanning out of the thick chordae tendineae into the thin, flattened leaflets of the mitral valve, which when closed form the vault above. Below are diagrams of the cardiac orifices, shown together on the upper surface of the heart, bottom right. They can be identified (from left to right) as the mitral, aortic, pulmonary, and tricuspid valves. An enlarged view of the H-shaped upper surface of the mitral valve is seen to the left, and on the lower edge of the sheet is a sketch of the vaulted shape of the closed mitral cusps as seen from the side.

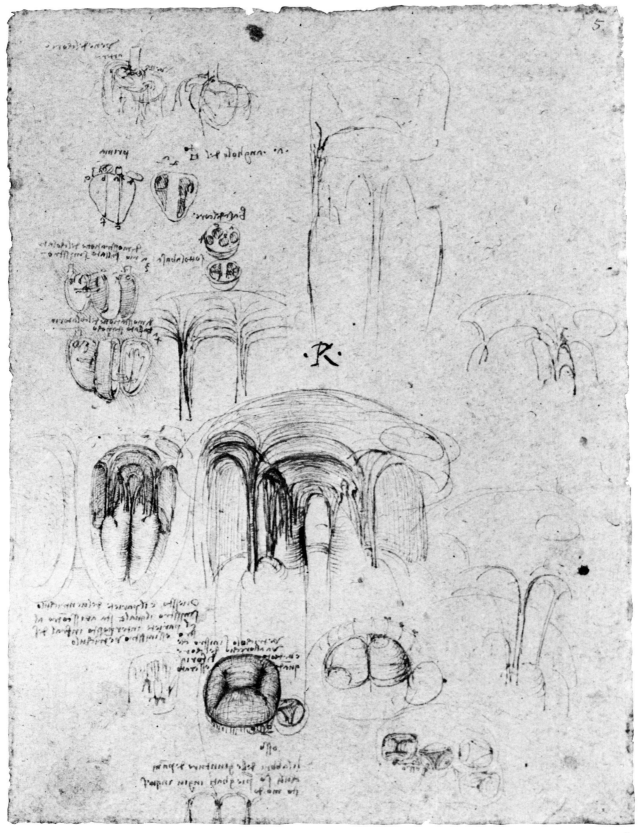

·R·

37A. The ventricles of the heart

Pen and dark brown ink on blue paper. 221 × 311 mm
(R.L. 19118–19v)

Like 35A, this sheet was formerly folded. The two small figures to the left of the fold show the surface of the heart (above) with the coronary vessels, and (below) seen from the apex to illustrate the area occupied by the right ventricle. Below these are three larger drawings of the inside of the right ventricle with the tricuspid valve, showing in the right-hand diagram the musculi pectinati of the auricle (bottom left), the papillary muscle seen through the tricuspid orifice (center), and the chordae tendineae radiating from this. In the left-hand diagram we are informed that "A is united with A." The three papillary muscles with chordae tendineae are evident.

On the right-hand side of the sheet are four diagrams of the ventricles of the heart, showing atrio-ventricular and arterial orifices, and a view of the mitral valve and aortic orifice. The drawings of the arm in supination and pronation bottom right should be looked at with reference to Leonardo's comments on 31A, among other sheets.

37B. The aortic valve and ventricles of the heart

Pen and dark brown ink.
(R.L. 19118–19R)

The left-hand side of this page is concerned chiefly with eddies made by blood flowing through the aortic valve, while the right-hand side concentrates on the right ventricle of the heart. In these drawings Leonardo depicts with great clarity the moderator band crossing the right ventricle. The vivid sense of space obtained in these drawings may well depend upon the technique that Leonardo here describes of "inflating and tying off" the various chambers of the heart "to see their shape." The lowest drawing on this side of the sheet shows the position of the moderator band in relation to the heart as a whole. Once again the heart dissected in these drawings is almost certainly that of an ox, in which the moderator band is more prominent than in the heart of a human.

38. The blood flow through the aorta

Pen and dark brown ink (two shades) on blue paper. 283 × 205 mm
(R.L. 19082R)

Inside the sketch of the aorta in the top right-hand corner Leonardo gives instructions for making a glass model in order to observe the movements of water, and so blood, as it passes through the aorta. He writes: "A form of gypsum to be inflated and a thin glass within, and then break it from head and foot by a–n. But first pour the wax into the gate of a bull's heart that you may see the true form of this gate." To the left are some projected models of the aorta with mobile aortic valve cusps to be fitted into the model.

In the formalized drawing on the right margin (below the study of the aorta) the cusps of the closing valve are likened to the yard and sails of a ship bellying out in the force of the blood behind them in ventricular systole. Leonardo writes: "Give names to the cordae that open and shut the two sails, i.e., the chief one you shall name brace and capstan, etc." Below this are drawings of eddies of blood passing through the aortic valve closing the cusps from the side, not from above. If the blood pressed from above it would merely crumple up the valve cusp as shown in the sketch at the upper edge of this page.

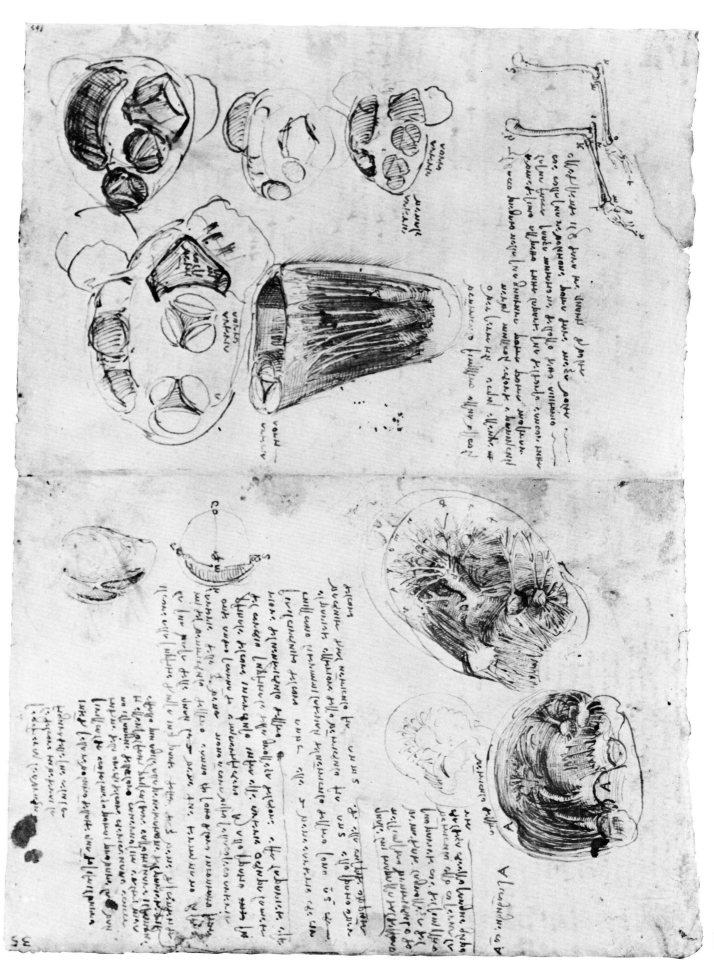

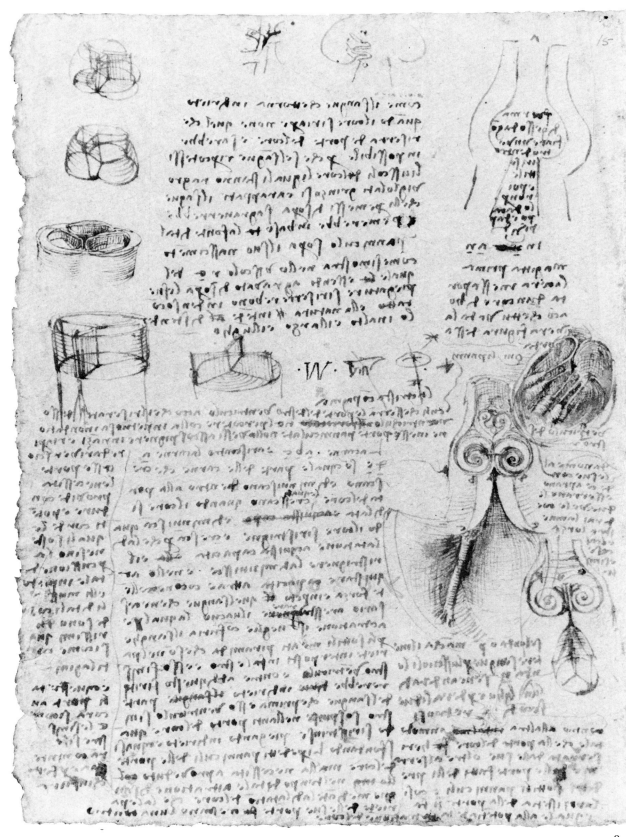

COMPARATIVE ANATOMY

THIS SECTION is intended to highlight the use made by Leonardo of his dissections of animals in order to aid and enrich his study of humans. It must always have been easier to obtain the bodies of wild or domestic animals on which to perform dissections than those of humans, and throughout his life Leonardo's anatomical models are usually animal. The early pages of the Early Anatomical Studies section contain many drawings of animal limbs. The injected brain (10), one of the studies of the fetus in utero (15A), and all the drawings of the heart (34–38) belong to ox or cow, while many of the drawings of lungs (e.g., 14) belong to the pig. Leonardo was well aware of similarities between animal and human anatomy. The drawings of the legs of man and horse on 42 show a clear instance of such a similarity. But he realized that a slight adjustment was sometimes necessary for this comparison: "To compare the structure of the bones of the horse to that of a man, you shall represent the man on tiptoe in figuring the legs." (See also entry for 49A.)

Leonardo was certainly aware that anatomical differences exist between man and beast. A note on 13B is typical of such awareness: "Describe the differences of the intestines in the human species, monkeys, and the like. Then how they differ in the leonine species, then in the bovine, and lastly, birds. And make this description in the form of a discourse." The intended discourse has apparently not survived. Both 13B and 42 should be dated in the first decade of the sixteenth century when Leonardo was chiefly occupied in the study of comparative anatomy.

39. *Four studies of the bones of a bird's wing*

Pen and brown ink (two shades) over
black chalk. 224 × 204 mm
(R.L. 12656R)

Leonardo carried out his most intensive investigations into bird flight during his second Florentine period, after 1499. His researches into this subject are summarized in the little treatise "Sul Volo degli Uccelli" (On the flight of birds) in the Royal Library, Turin, dated 1505. The present sheet is probably several years later than this and contemporary with the studies of the heart, about 1513–14.

The drawings represent dissections of a bird's wings, showing muscles and nerves, and the notes are concerned with the construction and action of a bird's wing. On another sheet (33B) Leonardo noted that the strength of a bird's wing lay in the fact that, as in humans, "no movement of the hand or its fingers is made by muscles that extend from the elbow upward . . . [and] all the muscles that lower the wings arise in the chest; these have in themselves greater weight than all the rest of the bird."

Leonardo's studies of birds' wings were naturally connected to his study of bird flight. During the 1480s and 1490s he invented numerous different types of man-powered ornithopter, all dependent on his notion that man had sufficient muscle power and skill to emulate birds. In later years, and certainly by the time the drawings on this sheet were executed, he abandoned these schemes.

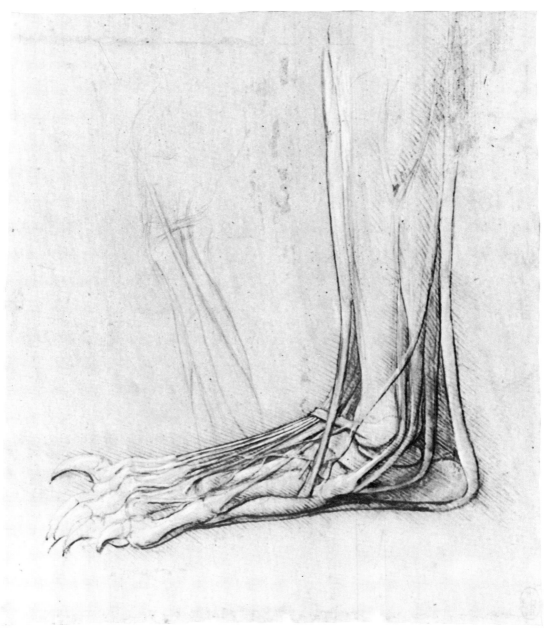

40

40. *The hind foot of a bear*

Metalpoint with pen and brown ink, heightened with white, on blue prepared paper. 161 × 137 mm (R.L. 12372R)

This drawing was originally catalogued as the foot of a monster, but it is now generally accepted that it represents the hind foot of a bear. Leonardo refers to the hunting of bears in the Chiavenna valley region on a page of the Codex Atlanticus, datable about 1490–93, and it is probable that this drawing can be dated around this time. He was evidently very interested in the structure of ligaments and bones of the fore and hind feet of animals, and around eighteen years later wrote (on R.L. 19061R): "I will discourse on the hands of each animal to show in what ways they vary; as in the bear, which has the ligatures of the toes joined above the instep."

41. *The thorax of an ox*

Pen and brown ink (two shades) and red chalk over traces of black chalk. 280 × 205 mm (R.L. 19108v)

Leonardo was always interested in the difficult mechanics of the muscles of the ribs and spine. He sensed unsolved problems in that region. In this series of drawings he pursues the question by dissecting an ox: the drawings down the left-hand side of the sheet are labeled *bo,* i.e., ox. The central drawing on this margin shows the longissimus dorsi muscle of the ox arising from the brim of the pelvis and ascending as what Leonardo calls a "compound" muscle to the upper thoracic spines. There is still the similarity to the stays of the mast of a ship mentioned in 24.

Apart from the drawings of floats on the right of the page, related to the studies of the movement of water on the verso (not exhibited), the remaining studies depict the muscles of the thorax and diaphragm (top left and bottom right).

42. *A comparison of the legs of man and horse*

Pen and dark brown ink with red chalk on red prepared paper. 281 × 205 mm (R.L. 12625R)

The fragmentary note in red chalk at the top of this sheet, mentioning an address in the Cordusio, the marketplace of the old center of Milan, enables us to date this drawing during one of Leonardo's stays in that city, probably 1506–7.

Beneath two beautiful studies of the surface markings of the legs are drawings of a man's pelvis and legs compared with the skeleton of the hind leg of a horse. The muscles of the thighs are represented by cords in both cases, to clarify their relative positions and actions. Leonardo's appreciation of the comparative anatomy of the legs of man and horse is shown by his remark on this page: "To compare the structure of the bones of the horse to that of man you shall represent the man on tiptoe in figuring the legs." Leonardo's treatise on the anatomy of the horse has been lost.

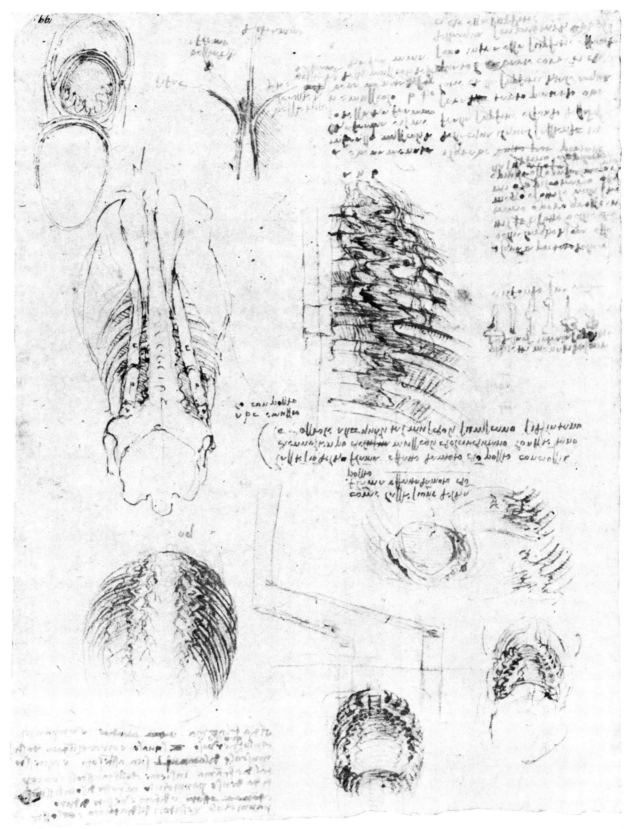

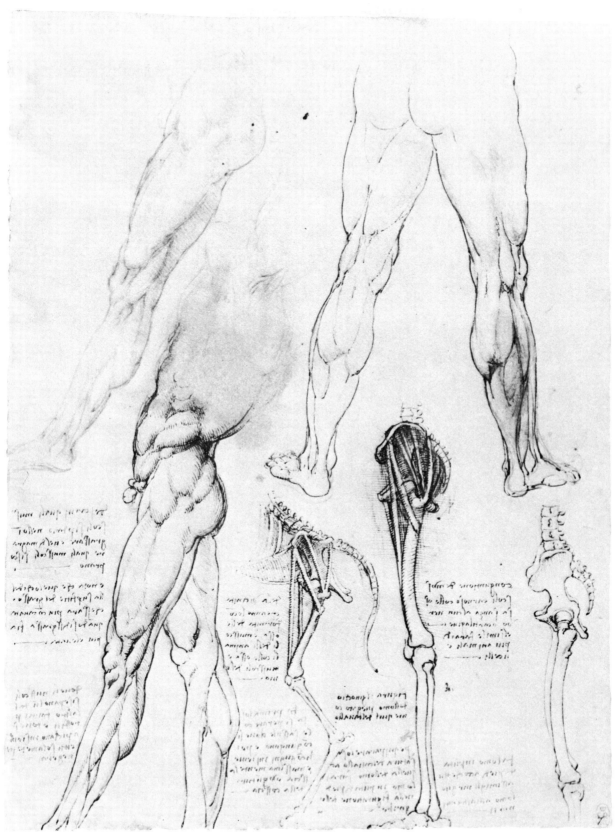

45A. The proportions of the leg and foot

Pen and brown ink (two shades). 405 × 281 mm (R.L. 19136–39V)

This sheet was originally folded twice, once vertically and once horizontally.

On this page Leonardo makes numerous statements concerning the relationships of different parts of the leg and foot to each other. He begins top right by asserting that the distances $a-d$ and $c-b$ on the drawing of the foot are equal to one head. Down the left-hand side of the sheet are a quantity of notes concerning the proportions of the leg, and others of a more miscellaneous nature, such as: "A lying man attains one ninth of his height." The diagram bottom right represents a system of pulleys with a weight of 2,000 pounds hanging at one end. Leonardo's notes below concern dynamics and conclude: "He who lightens the exertion lengthens the time."

45B. The proportions of the arm and trunk

Pen and brown ink (two shades) with some red chalk symbols on the left-hand side of the sheet. (R.L. 19136–39R)

Further parallels are here made between the dimensions of the parts of the arm and trunk. Beside the diagram top left Leonardo notes that the distance from the shoulder to the elbow equals that from the elbow to the knuckles, and beside that bottom left: "A man measures as much below the arms as at the hips."

46. Miscellaneous studies of human proportions

Pen and brown ink (two shades). 317 × 433 mm (R.L. 19134–35R)

This sheet was formerly folded down the middle, and the notes on the left-hand side of the sheet were added at 90 degrees to those on the right-hand side.

The notes down the right-hand edge continue those on 44 concerning the proportions of the face and head, and in the second column from the right they continue those on 45B concerning the proportions of the arm. The following passage is typical:

> The arm from the shoulder to the elbow, in bending, increases in its length, i.e., the length from the shoulder to the elbow; and this increasing is similar to the thickness of the arm at the joint of the hand, when it stands in profile, and similar to the space that is from the underside of the chin to the fissure of the mouth. And the thickness of the two middle fingers of the hand, and the size of the mouth, and the space which is from the attachment of the hairs on the forehead to the summit of the head—these said things are similar between themselves, but not similar to the above mentioned increasing of the arm.

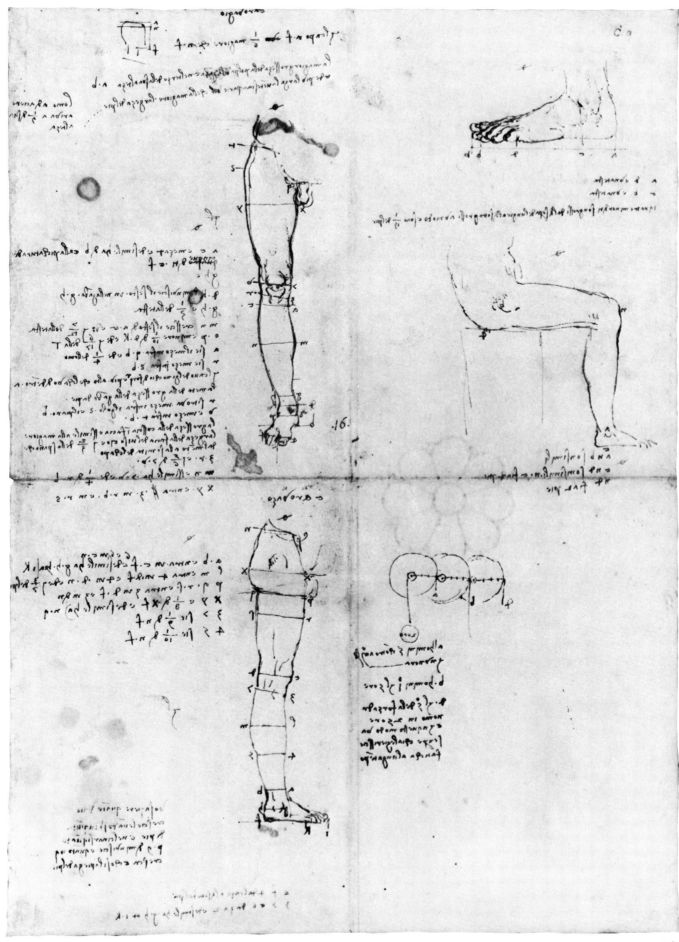

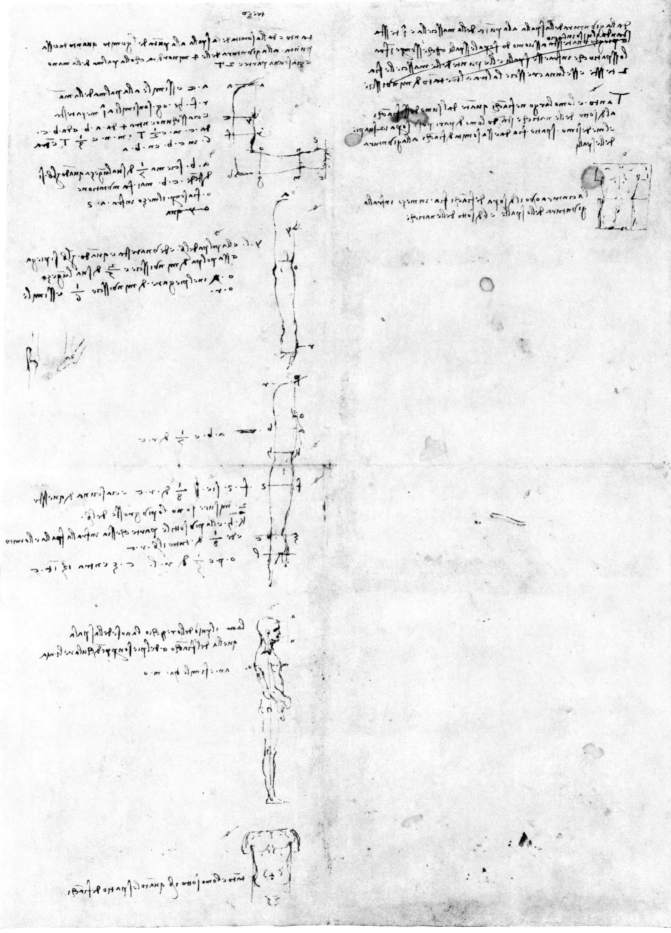

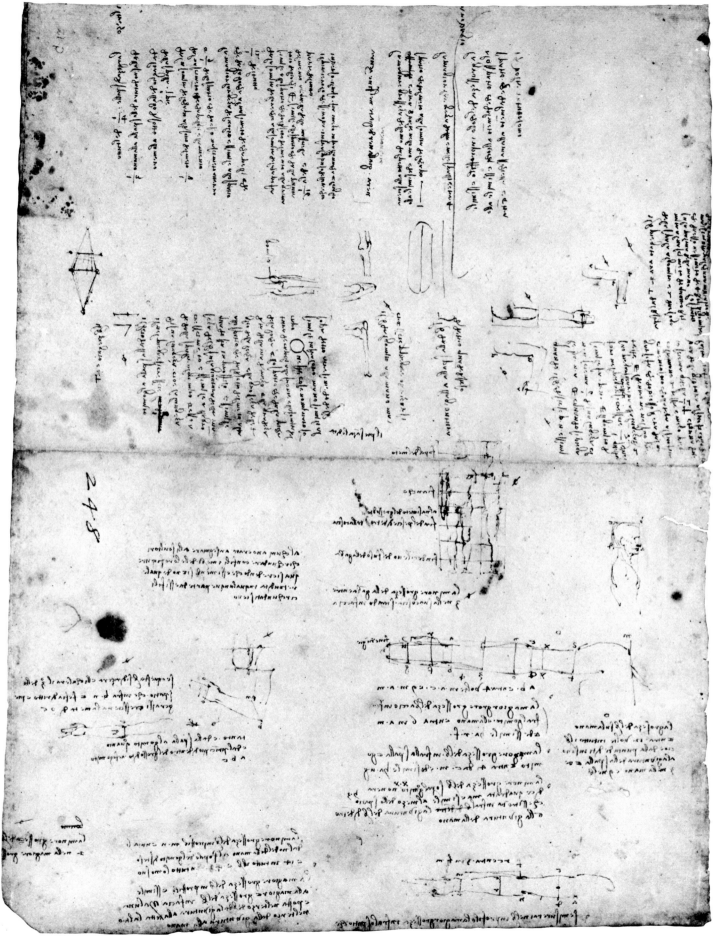

HUMAN PROPORTIONS

THE DRAWINGS in this section form part of a composite group of studies on human proportion, which was probably bound up as a notebook. The horse studies on 44 and the style of handwriting point to a date around 1490 for the group. From these pages it is clear that long before Leonardo turned to a detailed study of the human skeleton during the first decade of the sixteenth century, he had made himself aware of the relative sizes of the parts of the body and particularly how these were affected by movement of the joints.

These studies are all based on Leonardo's belief that the measurements of the different parts of man (and horse) can be shown to be related to one another by systems of direct proportion. Both 45 B and 46 are headed *il treço,* which doubtless relates to the model employed by Leonardo when carrying out these studies.

143

43. *Studies in human proportion*

Pen and brown ink (two shades).
160 × 218 mm (R.L. 19132R)

The theory of proportions seen in these drawings is explained in Leonardo's notes: "When a man kneels down he will diminish by the fourth part of his height. When a man kneels with his hands to his breast, the umbilicus will be the middle of his height, and similarly the points of the elbows. The middle of a man sitting, i.e., from the seat up to the summit of the head, will be below the mamma and below the shoulder. The seated part, i.e., from the seat to the top part of the head, will be as much more than half the man as is the thickness and length of the testicles."

44. *The proportions of the face, head, and body*

Pen and brown ink. 265 × 215 mm
(R.L. 12304R)

Down the right-hand margin of this sheet are nine small studies of the different parts of the human profile, with comments to the left as follows: "From the fissure of the mouth and the bottom of the nose [a−b] is a seventh part of the face. From the mouth to below the chin [c−d] is a fourth part of the face and similar to the width of the mouth. From the chin to the bottom of the nose [e−f] is a third part of the face and similar to the nose and the forehead. From the middle of the nose to below the chin [g−h] will be half the face. From the top of the nose, where the eyebrows begin, to below the chin [i−k] will be two-thirds of the face," and so on.

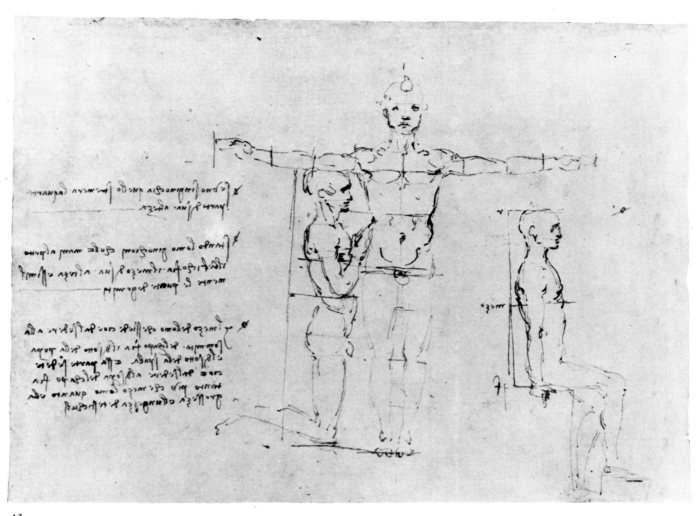

43

THE NUDE

LEONARDO'S anatomical studies had two purposes, of equal importance. First, to establish for his own purposes a clearer idea of the functioning of the human body, and second, to give him a greater knowledge of the musculature lying beneath the surface markings of the body, which he realized had frequently been represented inaccurately by artists (see note to 25A). It was particularly the body in movement that interested Leonardo and the different appearance of the body when certain limbs were flexed or muscles were taut or in repose. Something of the effect of the application of this knowledge on Leonardo's studies of the nude can be seen by a comparison between 47 and 50, whose execution was separated by a period of about fifteen years. The combination of art and science is seen to fine effect on 48, on which the drawing is closely connected to Leonardo's project for the *Battle of Anghiari,* while the notes, which are also related to the drawing, refer to the function and action of muscles of the foot and leg.

47. *Muscles of the arms and legs*

Metalpoint heightened with white on blue prepared paper. 174 × 140 mm (R.L. 12637R)

In this drawing Leonardo appears to be testing the emphasis of light and shade in bringing into relief the contours of the muscles of the arm and leg. The unusual conformations of some of the muscles of the arm and chest suggest that he had but limited knowledge as yet of these parts.

In the thigh he already tends to exaggerate the mass of the vastus lateralis on the outside of the thigh and gives it an erroneous tendinous insertion. The surface modeling of the abdominal muscles and buttocks have a delicacy typical of this early period of his anatomical studies (about 1490).

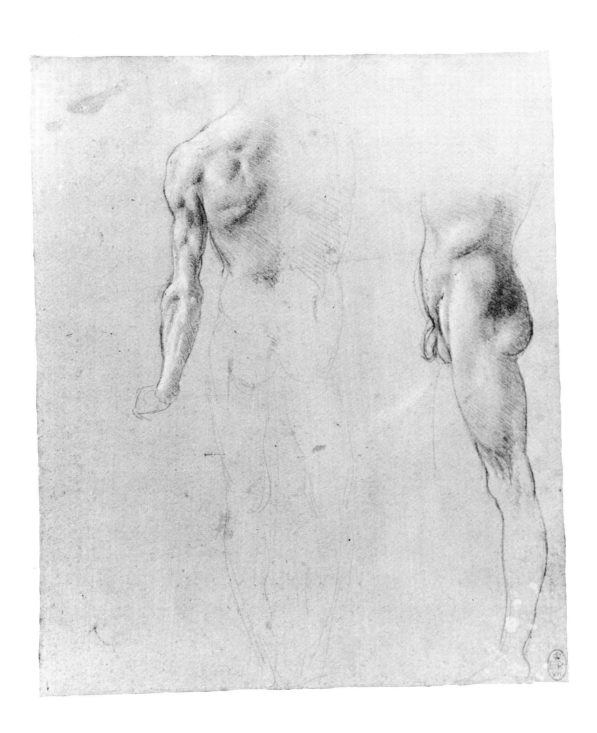

153

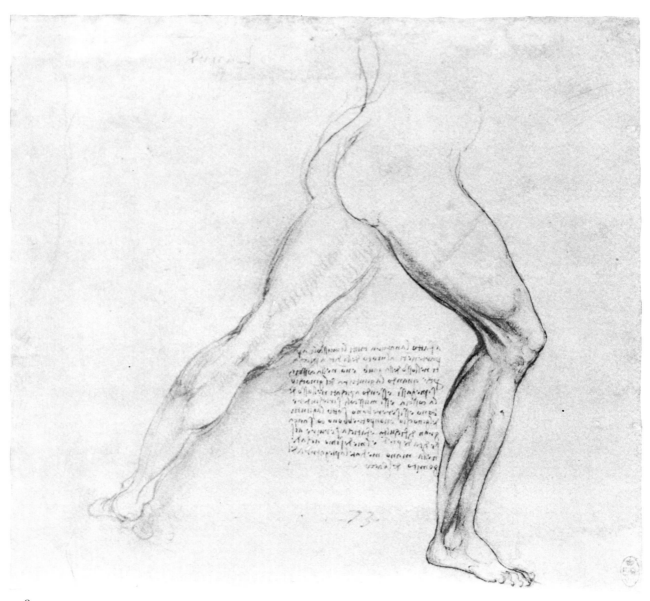

48

154

48. *Study of a nude man lunging to the right*

Red chalk with pen and dark brown ink, on terracotta-colored prepared paper. 157 × 166 mm (R.L. 12623R)

The motif of the lunging man was to be included in the left section of the mural painting of the *Battle of Anghiari,* commissioned from Leonardo by the city of Florence for the council chamber of the Palazzo Vecchio and worked on from 1503 to 1506. The note by Leonardo relates to the function and action of the muscles of leg and foot, as follows: "Nature has made all the muscles appertaining to the motion of the toes attached to the bone of the leg and not to the thigh, because these muscles, if attached to the bone of the thigh, would, when the knee joint should bend itself, close up and lock themselves under the knee joint and would not without great difficulty and fatigue be able to serve these toes. And the same happens with the hand, by means of the bending of the elbow of the arm."

49A. *External markings of the legs*

Black chalk with pen and brown ink. Outer measurements: 301 × 190 mm (R.L. 12631 and 12633R)

The two sheets of which 49 is composed have recently been shown by Carlo Pedretti to have been formerly joined together as a single sheet. At some time in the sixteenth century the drawings were separated and numbered "55" and "56"; they were also trimmed so that they cannot now be butted up exactly.

The two parts of 49A are clearly related and show the external markings of the legs of a man, emphasizing in particular the muscles of the thighs.

The note top left refers to the study of comparative anatomy and may be a sequel to the note on 42. The sheets are certainly close in date, and 49 should be dated about 1508. "You shall figure the legs of frogs, which have great similarity to the legs of a man, as well in the bones as in their muscles; then you shall let follow the hind legs of the hare, which are very muscular and with expeditious muscles, because they are not impeded by fat."

49B. *Musculature of the legs and study of a nude figure*

Pen and brown ink with black chalk. (R.L. 12631 and 12633V)

The figure of a standing nude with raised right arm must surely represent a piece of sculpture, probably a statuette, of the type that was often used in artists' workshops during the Renaissance.

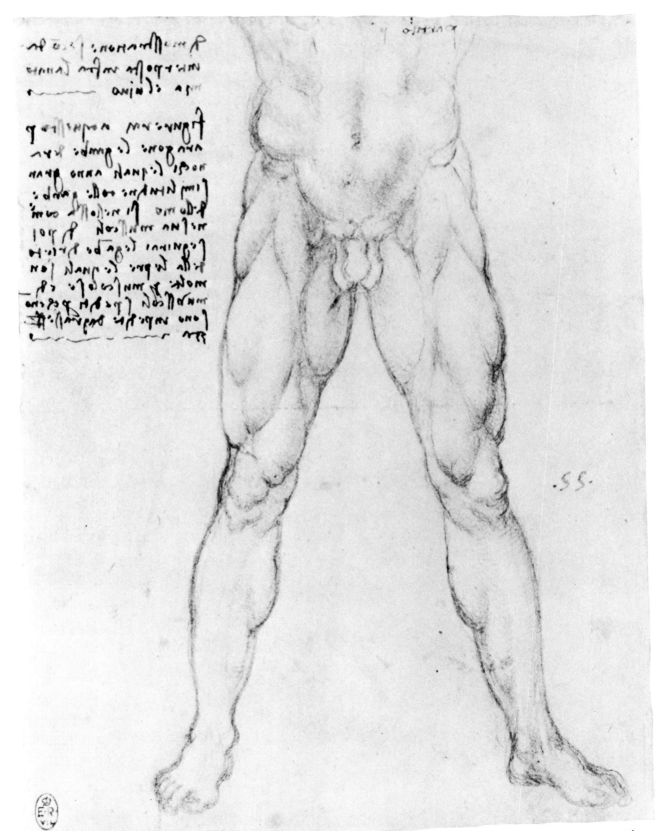

49A

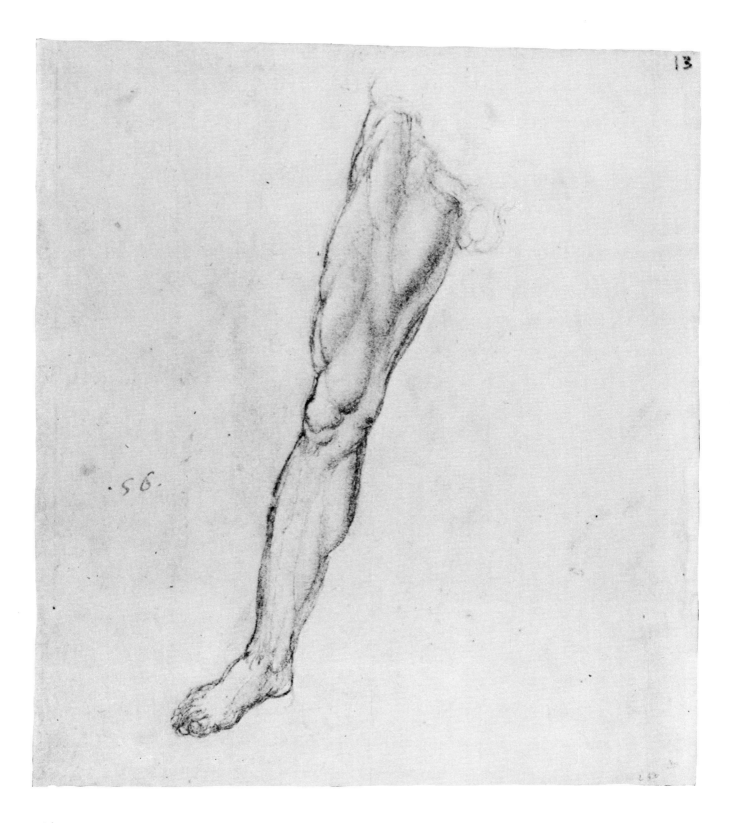

49A

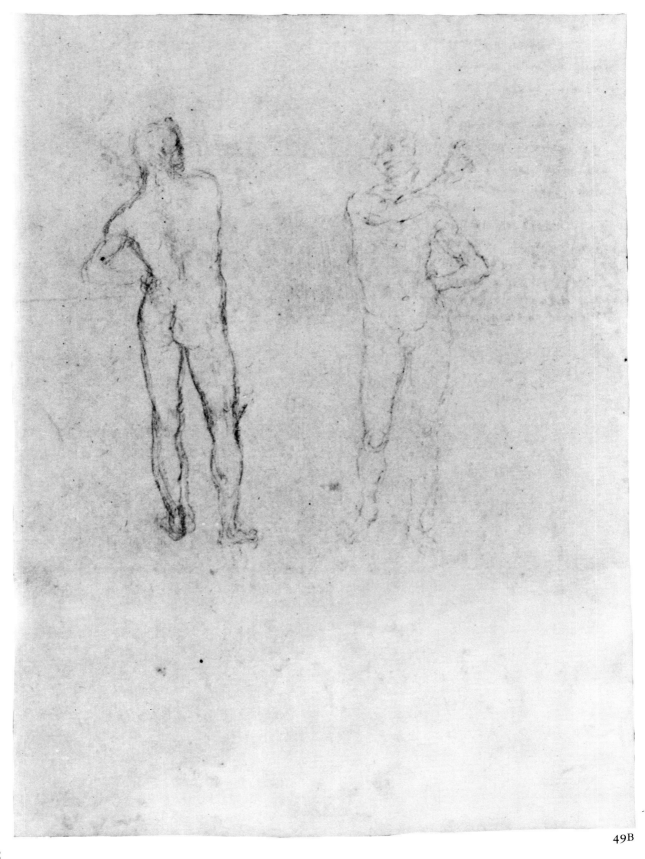

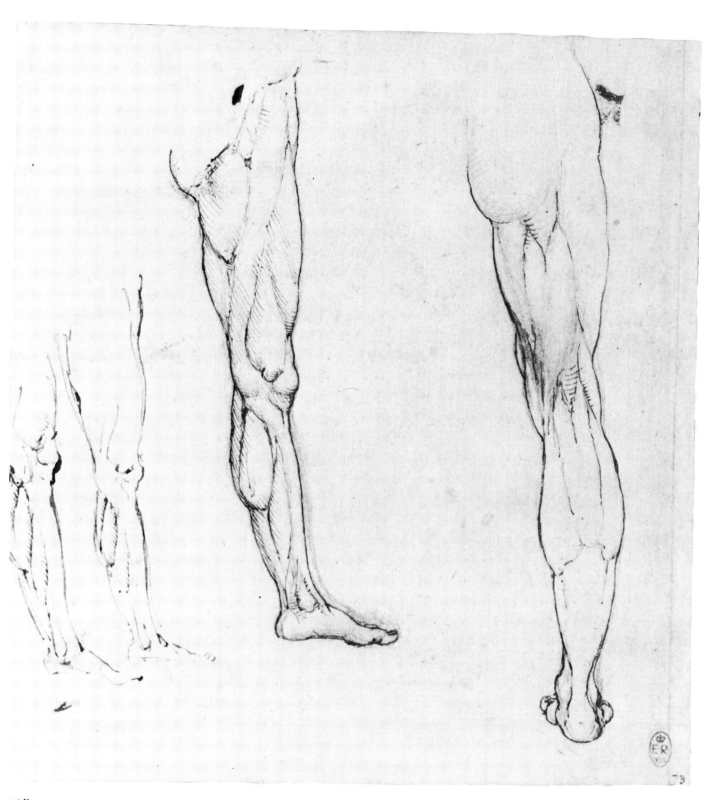

49B

50. *Male nude seen from the back*

Red chalk. 270 × 160 mm
(R.L. 12596R)

This powerful nude figure is apparently not connected with any finished project and instead represents Leonardo's mastery of the musculature of the human form. The modeling is extremely subtle, yet the muscles are almost invariably correctly drawn. Leonardo most frequently used red chalk for drawing in the last years of the fifteenth century, but this study probably dates from about 1503–7, that is, around the time of the Anghiari project.

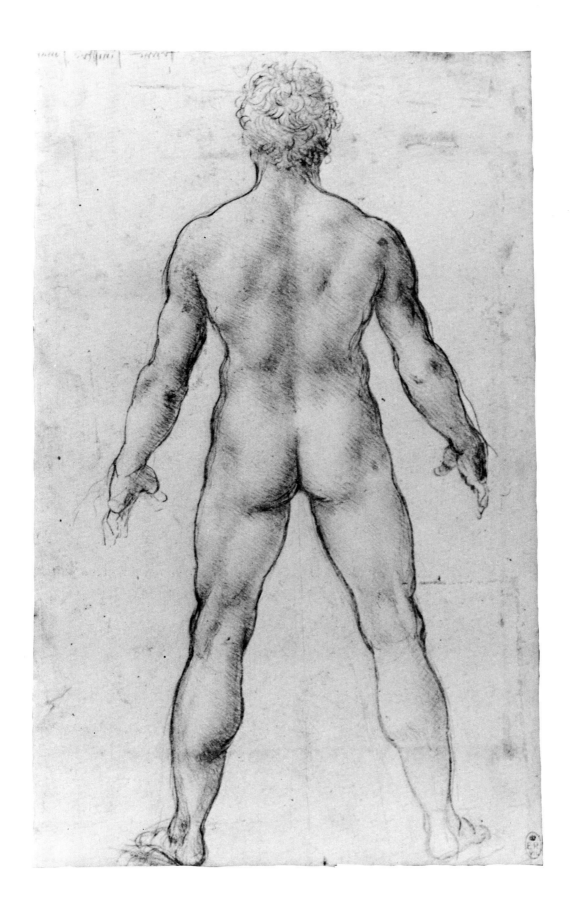

CHRONOLOGICAL TABLE

1452	Vinci	Birth of Leonardo
1470s	Florence	Leonardo's first dated drawing, 1473 Leonardo working in studio of Verrocchio *Ginevra de' Benci;* Uffizi *Annunciation*
1480s	Florence Milan	*St. Jerome;* unfinished *Adoration of the Magi,* 1481–83 Working in Milan, about 1483–99 *Virgin of the Rocks;* project for the equestrian monument for Francesco Sforza ANATOMICAL STUDIES: Metalpoint drawings of "Early Anatomical Studies" (3–7) Early sheets of Folio B, 1489 (8), showing particular interest in the head and brain
1490s	Milan	*Last Supper,* about 1497 Continued use of metalpoint for drawings (e.g., 47) ANATOMICAL STUDIES: No systematic studies, except on human proportion, about 1490 (43–46) Other miscellaneous studies (e.g., 1, 9, 16, 40, and 47)
1500s	Florence	Leonardo returns to Florence following French invasion of Milan Active as military engineer for Cesare Borgia, 1502–3 *Battle of Anghiari* project (48); *Virgin and Child and St. Anne; Mona Lisa; Leda and the Swan.* Red and black chalk drawings (e.g., 50)
	Milan	Returns to Milan 1506 and is appointed *Peintre et Ingénieur* to Louis XII of France, 1507 Project for Trivulzio monument ANATOMICAL STUDIES: In second part of decade great spate of renewed activity. Work on abdominal organs, skeleton, and musculature in later pages of Folio B, about 1505–8 (12, 13, 15, 17, 21–23) and in Folio A, about 1509–12 (20, 25–33). Also many miscellaneous studies (2, 10, 11, 14) and interest in comparative anatomy (42)
1510s	Milan/ Florence/ Rome/ France	Travels between Milan, Florence, and Rome in early part of decade, settling in Rome, 1513 *St. John the Baptist,* about 1514 Moves to France in 1517 and dies there, at Cloux, 1519, leaving all papers to Melzi ANATOMICAL STUDIES: Continuous activity in early years of decade, concentrating particularly on embryology (18, 19) and the the heart (34–38). Other miscellaneous studies (24, 39, 41)

GLOSSARY

LEONARDO'S TERMS

Imprensiva: a relay station in the brain for reception of the "impressions" produced by sensory stimuli. Leonardo devised and located this in the cerebral ventricles.

Nervo voto: the "empty nerve" refers to a hollow nerve fiber through which pass both motor and sensory stimuli. It is hypothetical, being part of the Galenic physiology of the nervous system.

Senso commune: a term derived from Aristotle, the sensorium commune is the place where all the senses converge. Here lies the "common sense" we still speak of today. Leonardo located it in the third ventricle of the brain, which he himself discovered. From "common sense" and "memory," located in the fourth ventricle, "judgment" arises—so ran the theory.

SOME ANATOMICAL TERMS

Brachial plexus: the network of interweaving nerves in the neck that supply the arm.

Buccinator muscle: a thin muscle lying between the upper and lower jaw, on each side of the face. It extends forward to join the lips. It is most forcibly used in blowing a trumpet; hence its name (*buccina* means "trumpet").

Chordae tendineae: delicate tendinous cords within the ventricles of the heart that join the papillary muscles (q.v.) of the heart to the membranous heart valves.

Cotyledons: parts of the placenta whereby the infant in the uterus is attached to the uterine wall. Indistinct in humans, they are separately formed in ruminants such as cows.

Deltoid muscle: a thick triangular muscle that covers the shoulder joint.

Dura mater: the external membrane covering the brain and spinal cord. It lies outside the other two membranes, the arachnoid and pia mater.

Interventricular septum: the muscular wall that separates the right ventricle from the left ventricle of the heart.

Maxillary antrum: a large cavity, about the same size as the orbit, lying in the cheek bone (maxilla).

Mitral valve: the valve of the heart lying between the left atrium and the left ventricle. It consists of two cusps, which together form the shape of a bishop's miter; hence its name.

Optic chiasma: the place where a large proportion of the optic nerves cross from one side to the other.

Papillary muscles: muscles within the ventricles of the heart, fixed to the heart wall at their bases while their apices project into the cavity and give origin to the chordae tendineae (q.v.).

Pectoralis major: a large triangular muscle that arises from the clavicle and the length of the sternum. All its fibers converge to be inserted into the upper end of the humerus.

Pulmonary artery: the artery that emerges from the right ventricle and supplies both lungs.

Pulmonary valve: the valve that guards the opening of the pulmonary artery from the right ventricle.

Saphenous vein: the great saphenous vein is the longest vein in the body, beginning on the inner side of the foot and ending in the femoral vein at the top of the thigh.

Sartorius muscle: this is the longest muscle in the body, running like a narrow ribbon from the front of the hip bone (anterior superior iliac spine) to the inner side of the knee.

Sesamoid bones: these "seedlike" bones lie in joint capsules. They vary from minute to the size of the kneecap (patella). Leonardo thought they diminished friction at the joint. Some still hold this view, but it is disputed.

Tensor fasciae latae: a muscle that arises from the iliac crest on the outer side of the sartorius and is inserted into the iliotibial tract on the outer side of the thigh. This tract is part of the fibrous sheath that surrounds the thigh. By "tensing" this iliotibial tract, the muscle steadies the leg in standing and it flexes the hip. Leonardo saw it as one of the main flexor muscles of the hip joint.

Tricuspid valve of the heart: the valve between the right atrium and the right ventricle, consisting of three main cusps, in contrast with the mitral valve (q.v.), which has two.

Vastus lateralis: a large muscle mass that runs from the upper outside side of the femur. It contracts into a tendon that is inserted into the outer side of the kneecap.

Vena cava: the superior vena cava drains blood from the upper part of the body, ending in the right atrium of the heart. The inferior vena cava conveys blood from the lower half of the body, passing through the diaphragm into the right atrium of the heart.

TABLE OF CONCORDANCE

The Internal Organs

1	12597R
2	12281R

Early Anatomical Studies

3	12627R
4	12617R
5A & B	12613R & V
6A & B	12609R & V
7	12626R

Head and Brain

8A & B	19057R & V
9A & B	12603R & V
10	19127R
11	19052R

The Alimentary and Reproductory Systems

12A & B	19031V & R
13A & B	19054V & R
14	19098V

15A & B	19055R & V
16A & B	19097V & R
17A & B	19095R & V
18A & B	19101R & V
19A & B	19102R & V

Muscles and Skeleton

20A & B	19007V & R
21A & B	19040R & V
22A & B	19020V & R
23A & B	19034V & R
24	19075V
25A & B	19005V & R
26A & B	19008V & R
27A & B	19003R & V
28A & B	19014V & R
29A & B	19002R & V
30A & B	19012R & V
31A & B	19000V & R
32A & B	19009V & R
33A & B	19011R & V

The Heart

34	19071R
35A & B	19073-74V & R
36	19080R
37A & B	19118-19V & R
38	19082R

Comparative Anatomy

39	12656R
40	12372R
41	19108V
42	12625R

Human Proportions

43	19132R
44	12304R
45A & B	19136-39V & R
46	19134-35R

The Nude

47	12637R
48	12623R
49A & B	12631 + 633R & V
50	12596R

The concordance of Royal Library inventory numbers with catalogue numbers is as follows:

Royal Library	Exhibition				
12281R	2	19000R & V	31B & A	19057R & V	8A & B
12304R	44	19002R & V	29A & B	19071R	34
12372R	40	19003R & V	27A & B	19073-74R & V	35B & A
12596R	50	19005R & V	25B & A	19075V	24
12597R	1	19007R & V	20B & A	19080R	36
12603R & V	9A & B	19008R & V	26B & A	19082R	38
12609R & V	6A & B	19009R & V	32B & A	19095R & V	17A & B
12613R & V	5A & B	19011R & V	33A & B	19097R & V	16B & A
12617R	4	19012R & V	30A & B	19098V	14
12623R	48	19014R & V	28B & A	19101R & V	18A & B
12625R	42	19020R & V	22B & A	19102R & V	19A & B
12626R	7	19031R & V	12B & A	19108V	41
12627R	3	19034R & V	23B & A	19118-19R & V	37B & A
12631 + 633R & V	49A & B	19040R & V	21A & B	19127R	10
12637R	47	19052R	11	19132R	43
12656R	39	19054R & V	13B & A	19134-35R	46
		19055R & V	15A & B	19136-39R & V	45B & A

BIBLIOGRAPHICAL NOTE

The numerical references in the text to drawings at Windsor are the Royal Library inventory numbers. These are the numbers used in the catalogue of the drawings by Leonardo da Vinci in the Royal Collection, in which each drawing is discussed and illustrated (*The Drawings of Leonardo da Vinci in the Collection of Her Majesty the Queen at Windsor Castle* by Kenneth Clark; second edition revised with the assistance of Carlo Pedretti, 3 volumes, London, 1968–69. Volume 3 of this series is by Carlo Pedretti and is devoted almost exclusively to anatomical manuscripts and drawings; see also Appendix C in volume 1 for a full discussion of their chronology).

The present exhibition has grown out of the work undertaken for the recent facsimile publication of all Leonardo's anatomical drawings in the Royal Collection: Kenneth Keele and Carlo Pedretti, *Leonardo da Vinci: Corpus of the Anatomical Studies in the Collection of Her Majesty the Queen at Windsor Castle*, 3 volumes, London and New York, 1978–80 (abbreviated as Keele and Pedretti). This edition supersedes the three publications issued around the turn of the century, as follows: *I manoscritti di Leonardo da Vinci della Reale Biblioteca di Windsor. Dell'anatomia, fogli A*, published by Teodoro Sabachnikoff, transcribed and annotated by Giovanni Piumati, Paris, 1898; *fogli B* in the same series published in Turin in 1901; *fogli C* published later as *Quaderni d'anatomia*, edited by O. C. L. Vangensten, A. Fonahn, and H. Hopstock, 6 volumes, Oslo, 1911–16.

Most of the anatomical drawings are also to be found in the following modern editions: *Leonardo da Vinci on the Human Body*, edited by Charles D. O'Malley and J. B. de C. M. Saunders, New York, 1952; Sigrid Esche, *Leonardo da Vinci: Das anatomische Werk*, Basel, 1954; and P. Huard, *Léonard de Vinci: Dessins Anatomiques*, Paris, 1968. Basic illustrations of Leonardo's anatomical studies include: Elmer Belt, *Leonardo the Anatomist*, Lawrence, Kansas, 1955; J. Playfair McMurrich, *Leonardo da Vinci the Anatomist (1452–1519)*, Washington and Baltimore, 1930; and *Leonardo da Vinci, il trattato dell'anatomia*, edited by A. Pazzini, 3 volumes, Rome, 1962. See also Carlo Pedretti, *The Literary Works of Leonardo da Vinci: A Commentary to Jean Paul Richter's Edition*, London, 1977.

Kenneth Keele, whose work has formed the basis of this catalogue, has written extensively on the subject of Leonardo's anatomical studies. A selection of these writings is given below.

"Leonardo da Vinci and Anatomical Demonstration." *Medical and Biological Illustration* 2 (1952):226.

Leonardo da Vinci on the Movement of the Heart and Blood. London: Harvey and Blythe, 1952.

"Leonardo da Vinci's Anatomical Drawings at Windsor." *Estratto dagli atti del convegno di studi vinciani*, Florence, 1953:76.

"The Genesis of Mona Lisa" (Beaumont Lecture, Yale University). *Journal of the History of Medicine and Allied Sciences* 14 (1959):135.

"Leonardo da Vinci's Research on the Central Nervous System, from Essays on the History of Neurology." *Proceedings of the International Symposium on the History of Neurology*, Varenna, Italy, 1961:15.

"Three Early Masters of Experimental Medicine—Erasistratus, Galen, and Leonardo da Vinci" (presidential address). *Proceedings of the Royal Society of Medicine* 54 (1961):577.

"Leonardo da Vinci's Influence on Renaissance Anatomy." *Medical History* 8 (1964):360.

"Leonardo da Vinci's Physiology of the Senses." *Leonardo's Legacy: An International Symposium*, edited by C. D. O'Malley, University of California Press, Berkeley, 1969:35.

"Leonardo da Vinci's Studies of the Alimentary Tract" (Beaumont Lecture, Yale University). *Journal of the History of Medicine and Allied Sciences* 27 (1972):133.

"Leonardo's Views on Arteriosclerosis." *Medical History* 17 (1973):304.

Leonardo da Vinci and the Art of Science. Hove, East Sussex: Wayland Publishers, 1977.

LIBRARY OF CONGRESS CATALOGING IN PUBLICATION DATA

Leonardo, da Vinci, 1452–1519.
 Leonardo da Vinci.

 Exhibition of drawings from the Royal Library at
Windsor, held Jan.–April 1984 at the Metropolitan
Museum of Art. Catalog prepared by Kenneth Keele and
Jane Roberts.
 Bibliography: p.
 1. Leonardo da Vinci, 1452–1519—Exhibitions.
2. Anatomy, Artistic—Exhibitions. 3. Windsor, House
of—Art collections—Exhibitions. 4. Windsor Castle.
Royal Library—Exhibitions. I. Keele, Kenneth D.
(Kenneth David), 1909– . II. Roberts, Jane.
III. Windsor Castle. Royal Library. IV. Metropolitan
Museum of Art (New York, N.Y.) V. Title.
NC257.L4A4 1983 741.945 83-13151|8
ISBN 0-87099-362-3
ISBN 0-87099-352-6 (pbk.)